A WORLD OF THEIR OWN
TWENTIETH-CENTURY AMERICAN FOLK ART

D0861199

A WORLD of THEIR OWN

TWENTIETH-CENTURY AMERICAN FOLK ART

THE NEWARK MUSEUM

This catalgoue was published in conjunction with the exhibition, *A World of Their Own: Twentieth Century American Folk Art,* organized by and on view at The Newark Museum from January 27 through May 14, 1995.

This exhibition and catalogue were funded in part by the Geraldine R. Dodge Foundation, Inc.

The Newark Museum receives operating support from City of Newark and State of New Jersey, The New Jersey State Council on the Arts/Department of State and Essex County. Funding for acquisitions and activities other than operations must be developed from outside sources.

LIBRARY OF CONGRESS CATALOG CARD NUMBER
95-3745

EDITOR
Vajra Kilgour, New York, NY

DESIGNER
Karen Davidson, New York, NY

PRINTER
Virginia Lithograph, Arlington, VA

COVER
Eugene Von Bruenchenhein
Untitled (No. 570), detail
1957, oil on Masonite
241/16 x 241/16 inches
John Michael Kohler Arts Center,
Sheboygan, WI

PHOTOGRAPHS
Unless otherwise noted, photographs
have been provided by the lenders.

ISBN 0-932828-31-0

CONTENTS

7 FOREWORD

Mary Sue Sweeney Price

8 PREFACE

Joseph Jacobs

10 A WORLD OF THEIR OWN
Twentieth-Century American Folk Art

Joseph Jacobs

41 BIOGRAPHIES

Artist Unknown ("Philadelphia Wireman")
Artist Unknown ("Master of the Woodbridge Figures")
William Blayney
David Butler
Henry Darger
Thornton Dial, Sr.
Sam Doyle
William Edmondson
Howard Finster
William Hawkins
Laura McNellis
John ("J.B.") Murry
Martin Ramirez
John Scholl
Bill Traylor
Eugene Von Bruenchenhein
Joseph Yoakum
Purvis Young
Willie Wayne Young

83 LENDERS TO THE EXHIBITION

84 WORKS IN THE EXHIBITION

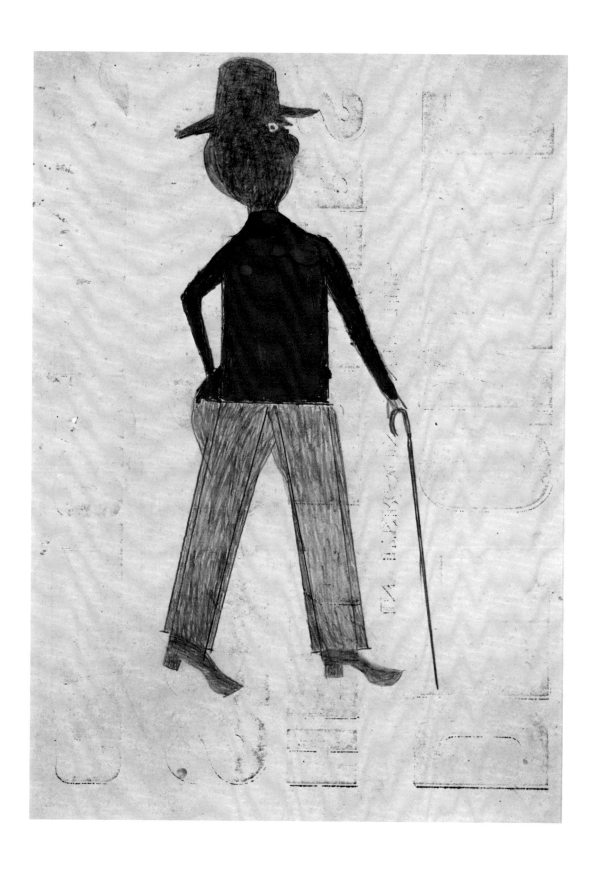

FOREWORD

From its inception in 1909, The Newark Museum has been dedicated to presenting, collecting, and interpreting American art. John Cotton Dana, the museum's founder and first director, did not limit American art to painting and sculpture; art included the decorative and industrial arts, which he found every bit as important and meaningful as the fine arts. Any manmade object that was well made and thoughtfully designed was a candidate for display so that others could learn from it. By presenting such work, the museum would spur inspired design and architecture, and it would encourage people to buy well-designed furniture and objects, and to create attractive living and working environments.

In this egalitarian spirit, The Newark Museum mounted the first museum exhibition of folk art in 1930. Titled *American Primitives: An Exhibit of the Paintings of Nineteenth Century Folk Artists* and organized by Holger Cahill, the show presented as art material that had previously been generally viewed as something less. And in 1931, the museum, again with Cahill as curator, presented *American Folk Sculpture: The Work of Eighteenth and Nineteenth Century Craftsmen*, a show that reinforced the belief that objects made by craftsmen had artistic merit. Not only was the work viewed as art, but it was viewed as American art, and was part of the museum's ongoing mission to discover our country's identity and significance as reflected in the visual arts.

With this same goal in mind, The Newark Museum presents *A World of Their Own: Twentieth-Century American Folk Art*. It seems only fitting as the century draws to a close that the first museum to present nineteenth-century American folk art now looks at the twentieth-century counterpart. The differences between the nineteenth- and twentieth-century work are dramatic, as the catalogue essay makes clear. The art in the exhibition looks different—much of it looks very modern, very abstract. Obviously, it was made in a different spirit. The circumstances have changed so much, it is even questionable if the art should be called folk art. Through *A World of Their Own*, The Newark Museum continues to explore the vital issues in American art, and in the spirit of John Cotton Dana, it continues to look at all kinds of art, placing equal emphasis on medium and genre.

Curator of Painting and Sculpture Joseph Jacobs has brought great passion and care to this project. I am grateful that he has continued the dialogue begun so long ago by The Newark Museum. I would also like to thank the Geraldine R. Dodge Foundation for its generous support of this project, and for its understanding of the importance of this very difficult and unusual material. I am pleased that the Foundation shares our commitment to education and is willing to join in our mission of studying and interpreting American art.

 —Mary Sue Sweeney Price
 Director

PREFACE

A World of Their Own was designed to reflect the preoccupation that has surfaced in the last fifteen years with painting, drawing, and sculpture by twentieth-century American self-taught artists and the labeling controversy that has swirled around this material. The premise behind the exhibition is simple: to demonstrate this curator's belief that the best artists work to a large degree in aesthetic isolation, and that this isolation, when coupled with powerful passions, results in unique styles and statements that defy categorization. To make this point, each of the nineteen artists selected for the exhibition produces work that is radically different from that of the other artists—and any other artists, for that matter. In effect, this uniqueness of style coupled with a dazzling formalist display and potent emotional content was the driving criterion for selecting artists.

Credit for the exhibition must go to Mary Sue Sweeney Price, Director of The Newark Museum, who enthusiastically supported the project from the moment it was first mentioned to her. I am extremely grateful for her understanding and appreciation of the art and her deep commitment to the show.

Of course, no exhibition is possible without the generous participation of the lenders. They are the backbone of any exhibition, and their importance is accorded by listing their names before the list of works in the exhibition, to which I refer the reader rather than repeating them here.

I would like to thank Phyllis Kind and Ron Jagger of the Phyllis Kind Gallery for sharing with me their enthusiasm for William Blayney, for helping to arrange many important loans, and for opening up their library to me; and I am deeply indebted to Phyllis for reading the catalogue manuscript and making insightful observations that resulted in my rethinking several passages. I am also greatly indebted to Roger Ricco and Frank Maresca for bringing the work of Laura McNellis and the "Master of the Woodbridge Figures" to my attention, for providing rare research material from the gallery library, and for helping to locate several major pieces in the show and arranging for key loans. I would also like to thank members of their staff—Anne Orlando, Susan Fingerle, Megan McGinley, and Laura Wiley—for their assistance.

I would like to thank John Ollman of the Janet Fleisher Gallery for helping locate work in the show and arranging for several major loans, and for providing research material and photographs. I am grateful to Carl Hammer for cultivating my appreciation of Henry Darger and Eugene Von Bruenchenhein and for providing information and photographs. William Fagaly of the New Orleans Museum of Art has been a wonderful friend in sharing his thoughts on twentieth-century self-taught artists and for leading me to J.B. Murry. Others who played a major role in providing information that was critical to my thinking about the exhibition are Barbara Cate, Bert Hemphill, Lee Kogan, Elsa Longhauser, Luise Ross, and Gerard Wertkin. I would also like to thank Bonnie Grossman of the Ames Gallery for providing information on Achilles G. Rizzoli, the one artist I very much wanted to include in the show but did not due to logistical limitations.

I would like to thank Katia Ullmann, the Librarian at the Museum of American Folk Art, and Margaret DiSalvi,

WILLIAM HAWKINS
First Ferris Wheel No. 2, 1985, enamel paint on Masonite, 57 x 47 inches, collection of Frank Maresca. Photograph courtesy of Ricco/Maresca Gallery, New York.

8

Librarian at The Newark Museum, for their tremendous help locating research material. Wendy Jeffers was wonderful for providing bibliographical material and invaluable insights on Holger Cahill, Edith Halpert, and Abby Aldrich Rockefeller. I am grateful to David Owsley for the inordinate amount of time he spent helping me track down information on the mysterious William Blayney, and to Gael Mendelsohn for providing information on the "Philadelphia Wireman."

I am grateful to the following, who supplied information, photographs, and/or valuable assistance for the exhibition and catalogue: Paul Arnett; Hildegard Bachert of Galerie St. Etienne; Gregg N. Blasdel; David Boehm of Robert Greenberg Associates; Claudia DeMonte and Ed McGowin; Richard Gasperi; Lynda Roscoe Hartigan of the National Museum of American Art, Smithsonian Institution; Ann Helene Iversen; Alison Ferris, Laureen O'Toole, and Patti Glaser-Martin of the John Michael Kohler Arts Center; Robert Manley of the Luise Ross Gallery; John M. MacGregor; Stacy Hollander, Tanya Heinrich, and Ann-Marie Reilly of the Museum of American Folk Art; Paul d'Ambrosio and A. Bruce MacLeish of the New York State Historical Association; Edward Thorp; Adam Weinberg and Ellin Burke of the Whitney Museum of American Art; and Amy Wolf.

I greatly appreciate the outstanding professionalism that Rena Zurofsky, the museum's Deputy Director for External Affairs, exhibited chaperoning this catalogue to publication, and I am grateful for her valuable encouragement and advice at key moments in this process. I am deeply indebted to Ward Mintz, Deputy Director for Programs and Collections, who was a terrific first reader for the manuscript; he offered many insights that helped focus the essay and dramatically improve it. It was a pleasure working with two top free-lance professionals on the production of the catalogue: Vajra Kilgour, who edited the manuscript, and Karen Davidson, who designed the publication.

I would like to thank Ruth Barnet, Curatorial Secretary of The Newark Museum, for obtaining photographs and reproduction rights and for preparing loan requests. I am extremely grateful to Susan Newberry and Lucy Brotman, the Director and Assistant Director of the Education Department, respectively, for their role in developing the education components of the exhibition. Other museum staff who were critical to the success of the exhibition include Diane Zediker for public relations, Robert Coates for exhibition design, Margaret Molnar for arranging for the loans and shipping, and Jane Rappaport for handling the logistics of the panel discussion. I am grateful to Peggy Dougherty and Marysue DePaola for their fundraising efforts, and to Barbara Lowell, Christine Hood, Patricia Faison, and Ellen Trama for handling the receptions and related marketing. Lorelei Rowars deserves special credit for obtaining important exhibition-related educational material for the museum's gift shop.

Lastly, I would like to thank Wendy Israel, my best friend, who throughout this project has been a font of advice and support, and my daughter, Sydney Elizabeth, who has been so patient with my long absences during this project.

—Joseph Jacobs
Curator of Painting and Sculpture

A WORLD OF THEIR OWN

TWENTIETH-CENTURY AMERICAN FOLK ART

n the opening decade of the twentieth century, an appreciation of folk art was limited to a handful of pioneers—anthropologists and decorative-arts collectors interested in artifacts and crafts, especially pottery. In the following decade, a tight-knit group of collectors, mostly artists, quietly began to acquire "primitive" painting and sculpture. This group centered on an artists' colony and school in Ogunquit, Maine, that was set up in 1913 by Hamilton Easter Field with the help of the sculptor Robert Laurent (**FIG. 1**).

Field was a wealthy artist and critic who, by 1909, had become an ardent convert to modernism. He toured Europe in the opening decade of the century, studying art and collecting Asian and African art and such modernists as Picasso. He also admired children's art—a taste he shared with Alfred Stieglitz, who showed children's works in 1912 in his New York gallery, "291." Field, like many European modernists, was attracted to primitive art. In the early twentieth century, primitive art was defined so as to encompass a broad range of work that did not conform to academic illusionism. Instead, this art had a strong design sense or abstract component that was believed to result more from intuition than from formal training. Or it might be art that showed little or no concern with the representational values of the art of Western civilization, and was therefore perceived as unsophisticated. Simplicity, directness, naïveté, and innocence were the hallmarks of the primitive, which came from societies or civilizations believed to be in early or arrested stages of development (Goldwater 1966). The nineteenth-century American folk painting and sculpture that Field found in the barns and shops in and around Ogunquit embodied these very qualities, which also happened to parallel the formal values of modernist art. Consequently, he began to collect it (Rumford 1980; Metcalf 1986; Metcalf and Weatherford 1988).

Field established the Ogunquit School of Painting and Sculpture, and, in 1920, the magazine *The Arts*, in order to promote his modernist aesthetic. His influence was so pervasive that Ogunquit became a summer mecca for such progressive artists as Robert Laurent, Wood Gaylor, Marsden Hartley, Stefan Hirsch, Bernard Karfiol, Yasuo Kuniyoshi, Niles Spencer, and William Zorach. These artists were startled by the material that Field had decorated their fishing cottages with: nineteenth-century primitive paintings, hooked rugs, decoys, chalk figurines, and toys. They, too, began collecting these objects, which Field called "Americana." Also acquiring this work at the time or shortly thereafter were Charles Sheeler, Charles Demuth, Alexander Brook, Peggy Bacon, and Viola and Elie Nadelman.

For this group of modernists, the attraction of early American painting and sculpture by self-taught artists lay in their simplified forms and abstract vocabulary, qualities that the modernists themselves were consciously introducing into twentieth-century art. Their own aesthetic concerns resulted in their cultivating an eye for this neglected nineteenth-century material. Sculptors such as Elie Nadelman, Zorach, and Laurent, who were recommending that artists work directly in wood, stone, and metal, as opposed to casting in bronze or having a workshop carve marble statues based on terra-cotta models, especially appreciated the folk artisans' hands-on approach, which reflected what they themselves were doing.

The first published appreciation of folk painting appeared in 1923 in an article in the *Worcester Museum*

Bulletin. It was written by the museum's curator, Raymond Henniker-Heaton, about an anonymous nineteenth-century painting in the collection, *Madame Freake and Baby Mary*. Henniker-Heaton praised the painting for its strong formal merits, which compensated for the deficiencies of its primitive technique (Rumford 1980, 14). In 1924, the painter Henry Schnackenberg organized the first folk exhibition, *Early American Art*, for the Whitney Studio Club in New York City, and Elie and Viola Nadelman opened the first folk art museum, the Museum of Folk and Peasant Arts, which was housed in a mansion in Riverdale, New York, built specifically for their collection. Their vast holdings contained both European and American folk art, and the didactic installations tried to put the work into a meaningful context when possible, often tracing the influence of European folk art on American. The museum was open to the public by appointment until 1934, when it was forced to close for financial reasons (Stillinger 1994).

Toward the end of 1924, folk art penetrated the commercial art world when the New York dealer Valentine Dudensing mounted a painting show, *Early American Portraits and Landscapes*. At the same time, Isabel Carleton Wilde, a Cambridge, Massachusetts, antiques dealer, began acquiring similar material, and by 1926 she was aggressively advertising in the magazine *Antiques*. Her collection was shown at the Whitney Studio Club in 1927, and it was the core of a 1930 Harvard Society of Contemporary Art show, *Exhibition of American Folk Painting in Connection with the Massachusetts Tercentenary Celebration*, organized by three university undergraduates. Edith Halpert also began selling folk art in the 1920s, having become an ardent advocate of the material after staying in 1926 at the Ogunquit colony, then being operated by Robert Laurent (Field had died in 1922). By 1929, she was exhibiting folk art at her Downtown Gallery, which she had opened in New

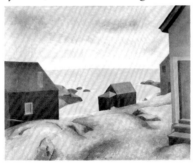

York in 1926 to promote contemporary art. In 1931, with Holger Cahill and Beatrice Goldsmith, she founded the American Folk Art Gallery in the same space. Goldsmith was the backer, while Cahill stocked the store and provided expertise on the objects (Jeffers 1994).

By now, folk art had become so popular that the demand exceeded the supply. No rural house in the Northeast was safe from prying "pickers," who were scouring the countryside in search of Americana. Tales of the tactics and ruses used to gain access to homes, the unlikely places treasures were found, and the negligible prices often paid became part of the lore of the folk art field.

To the dealers and collectors of the early 1930s, the term "folk art" conjured a complex yet specific set of images: primitive painting, trade signs, frakturs, hooked rugs, quilts, weathervanes, whirligigs, decoys, toys, chalk figurines, cigar-store figures, ship figureheads, and so on. All of this material was made in America in the eighteenth and nineteenth centuries, the most desirable before the Civil War. Folk art had become codified, and this was largely due to the influence of one man, Holger Cahill, and three exhibitions that he organized: two at The Newark Museum in 1930 and 1931, and a third at The Museum of Modern Art in 1932. While these exhibitions were the culmination of a decade and a half of growing interest in folk art, they were the vehicles for crystallizing that interest, transforming fashion into doctrine.

Born Sveinn Kristjan Bjarnarson in 1887 in Iceland, Cahill grew up in South Dakota and in Manitoba, Canada. In 1913, he arrived in New York, where he took courses in journalism and creative writing at New York University, and in art history and aesthetics at the New School of Social Research. He soon became an accepted figure in New York intellectual circles, befriending Alfred Stieglitz and the artists in his gallery, and the painters Robert Henri and John Sloan. Through his friendship with Sloan, Cahill was hired to promote the exhibitions of the Society of Independent Artists, which Sloan had founded. The success of his work for this

FIG. 1. NILES SPENCER
The Cove, 1922, oil on canvas,
28 x 36 inches, The Newark Museum,
Purchase, 1926, The General Fund,
26.4. This painting shows the cottages
at the Ogunquit colony.

FIG. 2. ARTIST UNKNOWN

Girl with Flowers, ca. 1840, oil
on canvas, 36 x 29 inches, The
Newark Museum, Purchase 1931,
Felix Fuld Bequest Fund, 31.145.

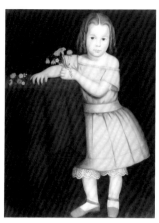

group—he attracted large crowds for the society's exhibitions—led John
Cotton Dana, director of The Newark Museum, to hire him to handle public
relations and catalogue the museum's collection. Dana had a profound influ-
ence on Cahill, and must be credited with playing a role in forming Cahill's
receptiveness to folk art and developing his attitudes toward the field (Metcalf
and Weatherford 1988; Vlach 1985; Jeffers 1991).

As head librarian of the Newark Public Library, Dana was a driving force
behind the founding of The Newark Museum in 1909 (Lipton 1979). He
conceived of the museum, which was originally housed in the library, as a
public-service institution rather than as a bastion of culture. Concerned that
museums had become warehouses for art and artifacts and social institutions
for the elite, he argued for a museum of all the people, one rooted in the
community and dedicated to teaching. The art objects "will be bought to give pleasure, to make manners
seem more important, to promote skill, to exalt hand-work and to increase the zest of life by adding to it
new interests" (Dana 1917, prologue). Toward this end, Dana established one of the first museum education
programs in the country, and his "art-mobiles," which still exist today under the auspices of the museum's
Lending Department, reflect his commitment to bringing the museum to the community (Lipton 1979;
Vlach 1985, 151–54).

In an age when painting and sculpture had exalted status in other institutions, Dana introduced a democra-
tic curatorial policy, giving equal emphasis to a wide range of media and disciplines. He insisted on the poten-
tial for art in all manmade objects, declaring that there could be fine design in everything. He believed
museums should present objects that could teach good design to craftsmen and artisans. Newark was a major
manufacturing city, and he tried to forge a bond between the museum and industry by working with company
heads and mounting exhibitions that would be of particular interest to them. In 1912, and again in 1922,
the Museum presented *Modern German Applied Arts*, an exhibition of well-designed manufactured products.
In 1928, Dana organized an even more audacious exhibition, *Inexpensive Articles of Good Design*, which
consisted of objects selected from local five- and ten-cent stores that demonstrated that "beauty has no
relation to price, rarity or age" (Coffey 1959, 13).

Dana was also a pioneer advocate for American art at a time when museums were oriented toward European
art and culture. In addition to numerous group exhibitions of contemporary Americans, he mounted one-
person shows for Childe Hassam, Max Weber, John Marin, and Stuart Davis, among others. When Holger
Cahill came to The Newark Museum in 1921, he found himself in a climate that emphasized American art
in every imaginable manifestation, especially in forms that might educate and benefit the entire community.

Cahill's introduction to American folk art occurred in 1926, while summering at the Ogunquit colony with
Edith and Samuel Halpert. He became passionately interested in this art, which coincided with Dana's inter-
ests. The two men *may* have discussed mounting a folk art show. Dana died in 1929, before any such exhibi-
tion was scheduled, but Beatrice Winser, who followed him as director, allowed the project to go forward,
giving Dana full credit in her foreword to the catalogue: "In presenting this group of primitives The Newark
Museum carries out an old plan of John Cotton Dana, who for many years had known and been interested
in this homespun type of American art" (Winser 1930).

American Primitives: An Exhibit of the Paintings of Nineteenth Century Folk Artists opened November 4, 1930.
It was a landmark exhibition, for it was the first museum show of the material, and the most ambitious exhi-
bition of its kind to date. It presented eighty-three paintings (**FIGS. 2–4**), watercolors, embroidered pictures,

tinsel pictures, and oils on velvet and glass, and was accompanied by an eighty-page catalogue, complete with bibliography. Cahill divided the work into three categories: "Portraits," "Landscapes and Other Scenes," and "Decorative Pictures." By presenting the material by subject matter, he established a precedent that would prevail into the 1960s. Lenders to the show read like a "Who's Who" of collecting: among the twenty-three listed were Wood Gaylor, Stefan Hirsch, Robert Laurent, Viola Nadelman, William Zorach, and Alexander Brook. The Downtown Gallery donated to the museum one of the pieces in the show, an 1862 "Flower Piece by Mrs. Waterhouse." After closing on February 1, 1931, the show traveled to the Memorial Art Gallery of the University of Rochester, in New York; The Toledo Museum of Art; and The Renaissance Society of the University of Chicago.

In his short introduction to the catalogue, Cahill accounts for his use of the word "primitive" by saying that it "is used as a term of convenience, and not to designate any particular school of American art, or any particular period." He uses it to underscore the artists' lack of training, which results in a crude naive directness but also in a strong formal vocabulary as well as an innate American quality. After explaining that the work was produced by "artisans and amateurs," who are "simple people with no academic training and little book learning," he says:

> The peculiar charm of their work results sometimes from what would be technical inadequacies from the academic point of view, distortion, curiously personal perspective, and what not. But they were not simply artists who lacked adequate training. The work of the best of them has a directness, a unity, and a power which one does not always find in the works of the standard masters. Many of the landscapes in this exhibition show a sense of design,

> an inventiveness, an imaginative force, and a feeling for decoration which more than one painter of great reputation might well envy (Cahill 1930, 7).

Cahill ends his introductory essay by pointing out that the American primitive painters had compromised their innocence by looking at high art, and their Americanness by looking at European art in particular:

> Some collectors have seen in these primitives an indigenous American growth, but even this simple art cannot be called altogether indigenous. Here as elsewhere, the European influence is at the heart

> of the native American development. Certain influences, Dutch or English mainly, are definitely recognizable. Most of these artists had seen paintings of one kind or another, or had seen engravings in books. It is evident that they tried to approximate effects achieved by academic artists whose paintings they had seen in the original or in reproduction (Cahill 1930, 9).

But if American primitive painting failed to be entirely American, folk sculpture did not, which was probably why Cahill included three wood sculptures in his painting show. On October 20, 1931, Cahill opened an exhibition devoted entirely to sculpture: *American Folk Sculpture: The Work of Eighteenth and Nineteenth Century Craftsmen* (**FIGS. 5–6**). In his catalogue essay, Cahill explains that the work has been selected because of its "aesthetic quality rather than technical proficiency," and praises it for its "value as sculpture." He points out that the work is produced by someone who

> is an artist by nature if not by training. This art is based not on measurement or calculations but on feeling, and it rarely fits in with the standards of realism. It goes straight to the fundamentals of art—rhythm, design, balance, proportion, which the folk artist feels instinctively (Cahill 1931, 13).

Following this modernist appreciation of the formal values, he stresses that the sculpture is made by "anony-

13

FIG. 3. ARTIST UNKNOWN
Mount Vernon, after 1800, oil on canvas, 24 x 30 inches, The Newark Museum, 1928, Gift of the Misses Rose and Helen Nichols, in memory of Walter S. Nichols and Mary E. Tompkins Nichols, 28.1310.

mous craftsmen and amateurs, carvers, carpenters, cabinet-makers, shipwrights, blacksmiths, stonecutters, metalworkers, sailors, farmers, and laborers," who, because they do not look at "fashionable art" and are not "the product of movements," create sculpture that is "folk art in its truest sense—it is an expression of the common people and not an expression of a small cultured class." More important, this work is a pure American expression:

The sculpture in this exhibition has significance for us as a genuine expression of the art spirit of the American people, and as a demonstration of the fact that talent has never been lacking in America even when opportunities for the study of art techniques have been very limited (Cahill 1931, 13–14).

The foreword to the catalogue was written by Arthur F. Egner, president of the board of trustees of the museum. His text further reflects the degree to which sculpture rather than painting was perceived both as pure folk art and as entirely American:

As charming as the paintings [in American Primitives*] were, we could not persuade ourselves entirely that we were viewing an wholly native expression of American growth....What is so stimulating about the present exhibit is that we have in it a truer and more indigenous expression of the American artistic sense.*

After discussing the functional nature of the exhibition's sculpture, Egner declares:

Here is another persuasive example of the truth of John Cotton Dana's constant assertion that articles of common and humble character may well be as significant expressions of Art as products of cost and circumstance (Egner 1931, 9).

At a time when modernism was controversial in America, and far from accepted by either the art establishment or the public, the discovery of folk art posited an American tradition from which the modernists might have descended, and suggested that contemporary modernism could be an American phenomenon, devoid of European influences. This supposition further justified supporting contemporary American artists, as Dana advocated, since Americans could create work equal to that of their European counterparts.

In 1932, Cahill added the last element to what would become the folk art formula: the assertion that it was specific to a period in time. This concept was introduced in a catalogue essay accompanying his third folk art show, *American Folk Art: The Art of the Common Man in America, 1750–1900*, for The Museum of Modern Art, where he was now acting director. This appointment reflects his close relationship with Abby Aldrich Rockefeller, a key trustee of the museum and an avid collector of folk art since the late 1920s; Cahill, along with Edith Halpert, was largely responsible for putting together Rockefeller's enormous collection. *American Folk Art* was organized to underscore folk art's relationship to modernism, showing how the folk material's use of formal vocabulary anticipated progressive twentieth-century art, and demonstrating that abstraction could be developed independent of European influences. The following year, Cahill organized *American Sources of Modern Art*, which was designed to make many of the same points as his folk art show.

Conceptually, *American Folk Art* was no different from the two earlier Newark Museum shows. The exhibition consisted of both painting and sculpture, and it was organized by medium, using such headings as "Oil Paintings" (**FIG. 7**), "Watercolors," "Paintings on Velvet," "Wood Sculpture," "Sculpture in Metal," and "Plaster Ornaments." Cahill's essay, however, presents the material with a slightly different slant. In his Newark Museum catalogues, he describes the work as being made by artisans and associates it with the eighteenth

FIG. 5. THOMAS J. WHITE (ATTRIBUTED TO)
Captain Jinks of the Horse Marines, 1879,
painted wood, 75 inches high, The Newark
Museum, 1924, Gift of Herbert E. Ehlers, 24.9.

and nineteenth centuries, but never says that folk art ceased to exist in the twenti-
eth century. He now states emphatically that folk art is the product of an agrarian,
preindustrial, craftsman society, declaring that it was a rural phenomenon that
became extinct by the time of the Civil War due to the rise of industry and the
growth of an urban society:

> *Folk art had a place in the life of this country from the early days of coloniza-
> tion up to the Civil War. After the Civil War it began to languish. The shift of economic
> and social forces which culminated in the war between the states was a function of the
> development of modern industrialism. Men and women were drawn away from the farm
> and from home industries into the factories…. By 1865 the United States had turned
> the corner from a rural to an urban civilization…. Business enterprise made use of the
> limitless reproductive power of the machine to fill the land with machine-made copies of
> objects designed by the craftsmen whom the machine was destroying* (Cahill 1932, 8).

The impact of Cahill's statement was tremendous. Not only was folk art decreed
dead, but with its demise went an entire way of life. Folk art became a symbol for an extinct world, whether
Cahill intended it to be or not. Gradually, it came to represent a homogeneous, agrarian, Jeffersonian America
populated by righteous, self-sufficient, hardy, independent European-Americans. One could add that it was
even perceived as the output of a period of greater creativity and cultural freedom, since the mechanization
and industrialization that displaced it had a numbing effect on individual creativity. Folk art now represented
a lost age of innocence.

With this shift away from the modernist to the historical implications of the work, the status of folk art as
art was compromised. It could be, and was, admired for its aesthetic qualities. Continuing a tradition begun
by Hamilton Easter Field, it was not uncommon for those writing on the subject to compare primitive portrai-
ture to the portraits of Picasso. But folk art was now perceived as artifact as much as art. By 1932, Cahill
himself was saying folk art was not great art. In the introduction to his 1932 *American Folk Art* catalogue,
after declaring that "the bulk of the material in this collection is an overflow from the crafts" (Cahill 1932,
4), he adds, "Folk art cannot be valued as highly as the work of our greatest painters and sculptors, but it is
certainly entitled to a place in the history of American art. When compared with the work of our secondary
masters it holds its own very well" (Cahill 1932, 27). Folk art was already close to not being considered art.
When Cahill himself described it as "an overflow from the crafts," the situation became perilous. Dana would
not have been pleased.

Once folk art began to be identified with early American history, it only made sense that it be acquired by
those institutions specifically dedicated to documenting that period. Although some fine arts museums such
as The Newark Museum, the Metropolitan Museum of Art, and The Museum of Modern Art acquired a signif-
icant number of works, for the most part folk art was collected by historical societies, and this shift away
from art museums had the effect of further downgrading the work's status as art. In a related development,
a growing preoccupation with American history led to the founding of Greenfield Village, Colonial Williamsburg,
Old Deerfield Village, Old Sturbridge Village, The Shelburne Museum, and Mystic Seaport in the 1930s and
1940s, and it probably contributed to the establishment of period rooms in the American wing of the
Metropolitan Museum of Art in 1924. Dedicated largely to the colonial, Federal, and Jacksonian eras, the
historical sites became natural repositories for folk art. Henry Ford's collection was placed in historic
Greenfield Village in Dearborn, Michigan; the Abby Aldrich Rockefeller collection ended up at Colonial
Williamsburg; and Electra Havemeyer Webb's collection was the foundation for The Shelburne Museum, to
mention a few examples.

In 1935, Cahill was appointed director of the Federal Art Project, and in this capacity he was responsible for creating the Index of American Design. The Index was in part inspired by documentary photo archives that John Cotton Dana had established at the public libraries in Denver, in Springfield, Massachusetts, and in Newark, where he had been head librarian (Cahill 1950, x). Although not devoted exclusively to American subjects, Dana's archives sought to define what was American about American art and to serve as important source material for artists and designers in the machine age. Cahill had the same goals for the Index, for which hundreds of artists were hired to make drawings of objects of the "practical, popular and folk arts of the peoples of European origin who created the material culture of this country as we know it today" (Cahill 1950, xii). Twenty-two thousand drawings were made of decorative, industrial, and vernacular objects from the eighteenth century to the 1890s.

The project was to cover the entire United States, with each object being thoroughly researched, documented, and put into proper historical context. However, because of staffing problems, little research was produced, and the Index ultimately focused on work made in the Northeast. Beginning in the late 1930s, plates from the Index were displayed in museums and department stores throughout the country, and as accompanying catalogues made clear, the images were similar to the Americana presented in Cahill's exhibitions at The Newark Museum and The Museum of Modern Art (Vlach 1985). By World War II, American folk art had saturated the nation, and the image the public had of this material was Holger Cahill's: it was a white, rural, American phenomenon predating the twentieth century.

Why was this view of folk art so narrow, and why were people so willing to look at the material in a limited context, with little concern for studying the complex social and cultural conditions that nurtured the work? Cahill himself acknowledged this serious shortcoming in the introductions to his exhibitions, pointing out that the field was new and little was known. But in large part, a simplistic, nostalgic vision of America's past satisfied many of the needs of prewar America, offering as it did a sense of solidity and assurance in a period of dramatic social transformation. As Eugene W. Metcalf, Jr., pointed out in his 1986 essay "The Politics of the Past in American Folk Art History," America was undergoing rapid urbanization and industrialization in the 1920s and 1930s. The machine age brought on a fear of standardization and dehumanization. Mass immigration, labor upheavals, and racial and class struggles made American society appear unstable. The result was a "cult of Americanism." As Metcalf writes in his article,

> America and its founders and institutions were glorified. Admiration for American history approached an almost religious fervor, as Americans lauded the virtues of democracy, freedom, and the American (Anglo-Saxon) common man who was said to be the bulwark of American society (Metcalf 1986, 39).

Americans were now not only learning to appreciate their own country's history; they wanted to escape a troubled present to live in the seemingly more innocent past. They did this nostalgically, through folk art.

THE LABELING PROBLEM

The present-day concept of folk art is much more complex than the one that was codified in the 1930s, and despite the simplistic image that prevailed by 1940, many people already knew better by then. Even Cahill, in the introduction to his 1932 Museum of Modern Art exhibition, acknowledges the existence of other types of folk art besides pre–Civil War Americana, citing in particular a variety found in the Southwest, which has a "marked Spanish influence, is largely religious in character, and is related to Mexican colonial art" (Cahill 1932, 8). A more pressing issue, however, was how to deal with those twentieth-century artists who perhaps could be labeled "folk artists." If folk art had disappeared with the Civil War, then what were those contemporary artists who were largely self-taught and worked in a primitive-looking style? Cahill had

even acknowledged the existence of such people in the introduction to his 1930 Newark Museum catalogue:

> The work of living men might have been included [in the exhibition], for there are many interesting folk artists painting in this country today. Their work finds its way into big annual no-jury shows, the New York dealers' galleries, and even into the Carnegie International (Cahill 1930, 7).

Cahill went so far as to make a foray into the twentieth century by including Joseph Pickett in his shows at The Newark Museum in 1930 (**FIG. 8**) and The Museum of Modern Art in 1932. In his 1932 catalogue, Cahill clearly labeled Pickett a folk artist in defending his use of the term "folk art" to describe all of the artists in the show, for by 1932 such terms as "naive," "primitive," "popular," "provincial," and "folk" were all current. Referring to the work in the exhibition, Cahill wrote:

> "Folk art" is the most nearly exact term so far used to describe this material. It fits very well the work of such men as Joseph Pickett, Edward Hicks, John Bellamy, and other strong personalities thrown up from the fertile plain of every-day competence in the crafts (Cahill 1932, 6).

But by 1938, Cahill no longer described Pickett as a folk artist. In that year, he was the curator for the American section of a Museum of Modern Art exhibition titled *Masters of Popular Painting: Modern Primitives of Europe and America*. The American artists included Emile Branchard, Vincent Canadé, Robert Cauchon, Pedro Cervantez, Chester Dalson, Edward Hicks, Thorvald Arenst Hoyer, "Pa" Hont, John Kane, Lawrence Lebduska, Joseph Pickett, Horace Pippin, and Patrick J. Sullivan. The European section was selected by Andry-Farcy, director of the Grenoble Museum, and included André Bauchant, Camille Bambois, Dominique-Paul Peyroynet, René Rimbert, Henri Rousseau, Séraphine Louis, and Louis Vivin. The show was the third in a series of exhibitions that focused on "some of the major divisions or movements of modern art," as defined by Alfred Barr, director of The Museum of Modern Art, in his catalogue preface. The first show in the series was *Cubism and Abstract Art*; the second was *Fantastic Art, Dada and Surrealism*. Both were presented in 1936.

In his preface, Barr states emphatically that the painting in the exhibition is *not* folk art: "The purpose of this exhibition is to show, without apology or condescension, the paintings of some of these individuals, not as folk art, but as the work of painters of marked talent and consistently distinct personality." The key issue for Barr is that the artists express strong personalities through highly individualistic styles. As far as he is concerned, they make *art*, not folk art—which, therefore, is not art. Barr emphatically points out that no anonymous works have been included in the show, a statement that suggests a belief that folk art is in a sense an anonymous genre, a generic expression of community values, in contrast to the unique and highly individualistic work in the show (Barr 1938, 9).

In his catalogue essay, "Artists of the People," Cahill's position is similar. He never calls the twentieth-century artists "folk artists." Nor does he call them "primitives," the label used in the subtitle of the exhibition and rejected or ignored by all of the essayists. The artists are simply "popular painters," and their work is called the "art of the common man"—the same description Cahill used for the work of nineteenth-century folk artists in his earlier catalogues. Although he never calls them "craftsmen," the popular painters, like their nineteenth-century predecessors, are self-taught and make their work not by studying other art but by

responding to their immediate world. Cahill describes them as "masters of reality":

> *It would be a mistake to apply naturalistic and academic standards to the work of these masters of popular art. And yet these artists may be called, as they have been called, "masters of reality." So far as realistic effect is concerned they are in harmony with the best contemporary practice. They are devoted to fact, as a thing to be known and respected, not necessarily as a thing to be imitated. Surface realism means nothing to these artists.* With them realism becomes passion and not mere technique. *They have set down what they saw, but, much more, they have set down what they knew and what they felt* (Cahill 1938, 98; emphasis added).

Cahill continues his discussion with a lengthy diatribe against "internationalized academicism," meaning contemporary abstract art based on formalist theories coming from Europe, especially Paris and London, since the late nineteenth century. He argues for a modern art that deals with the human condition, and, if made in America, then the American condition. "Popular art" met this criterion.

Puzzlingly, Cahill included Edward Hicks, a nineteenth-century "primitive," in his exhibition of twentieth-century painters, explaining that Hicks has a unique style stemming from powerful emotional responses, which links him to his twentieth-century successors. His work has "the same fresh unexpectedness of personal style" and the same "innocence and intensity of vision" as the work of the later painters. Cahill boasted that Hicks "may be called an American Rousseau, who antedates the *douanier* by half a century" (Cahill 1938, 100). Henri Rousseau was the great modern primitive, the darling of the Parisian avant-garde at the turn of the century whose status was equally high in America. Since self-taught artists are generally not influenced by other artists, Rousseau cannot be viewed as the beginning of a historical movement, but he was an emblem of the twentieth-century self-taught artist. He was not American, he did not work in a rural environment, and since he flourished from the last decades of the nineteenth century through the first decade of the twentieth, he was perceived as modern, an associate of Apollinaire and Picasso. Robert Goldwater, in his 1938 study *Primitivism in Modern Art*, described him as a "naive," and removed him from the category of folk art (Goldwater 1966, 178–191). By extension, the American twentieth-century artists who operated on premises similar to Rousseau's were also not folk artists.

By reaching back to Hicks, Cahill made a claim for the importance and independence of American art. But was he also trying to retrieve Hicks from the category of folk art and classify him as whatever it was that Rousseau was? Cahill seems to have realized that the concept of folk art as encompassing anything not made by an academic artist or craftsperson was perhaps far too broad.

The European curators were as preoccupied with labeling as Cahill, and for the same reason: the twentieth-century work they found themselves confronting was not folk art. In his catalogue essay, titled "Maîtres Populaires de la Réalité," Maximilian Gauthier rejects the terms "naives," "instinctives," and "modern primitives," claiming that all are somewhat pejorative. He explains his preference for "maîtres populaires de la réalité" by pointing out that "populaires" ("popular") recalls "their folk origin, the magnificent simplicity of feeling and thought which is in their pictures; 'réalité' ("reality") reflects the fact that "the Universe is only a reflection of our soul. Vivin's dream is his reality" (Gauthier 1938, 23).

Like Cahill, Gauthier praised the self-taught artists for painting their emotional response to their immediate environment; the presence in the work of the artist's passion is a key element. Gauthier goes so far as to call the paintings "poetry," and emphasizes the psychological overtones of the work by correlating "dreams"

and "reality," suggesting that the artists were able to paint a subconscious reaction to reality: it is the artist's innermost soul that is embedded in the paint (Gauthier 1938, 23). In fact, much of the European work selected for the exhibition has the same disconcerting juxtapositions, bizarre motifs, and dream images found in the painting of such surrealist artists as René Magritte, Max Ernst, and Salvador Dalí. It is probably not a coincidence that *Masters of Popular Painting* followed *Fantastic Art, Dada and Surrealism* as the third exhibition in a series designed to define modern art.

It is logical that twentieth-century self-taught art should appeal to the proponents of surrealism. The surrealists themselves were interested in the primitive. In their own work, they sought to expose the subconscious, the innermost human passions, and the basics of human nature as revealed by psychology. As a result, they were infatuated with cultures, classes, or groups that they believed were able to make art unselfconsciously. Children, "primitive" civilizations, and the insane met this criterion, and, to some degree, so did self-taught artists. The language used by Gauthier indicates that he felt that the artists in the show worked outside the conventions of civilization to express their innermost feelings poetically. The powerful and unique formalist vocabulary that resulted from the expression of feelings was the premise for The Museum of Modern Art exhibition, but clearly Barr, Cahill, and the Europeans were interested in the passion for its own sake, and for the way in which it exposed the innermost recesses of the mind.

Sidney Janis, a New York art dealer, also became an ardent supporter of contemporary self-taught painting, and had a major influence on the development of an appreciation for this material. Like the curators for *Masters of Popular Painting*, he limited his interest to painting, and, like everyone else, he was uncertain how to classify it. He did not deal with sculpture, which may have been too closely identified with folk art. Janis's chief interest was in full-blown artworks that bore no resemblance to utilitarian or craft objects. Furthermore, his interest in the material was conditioned perhaps as much by an appreciation of surrealism as by an understanding of modernist formalism.

Janis's support of contemporary folk art was expressed in two projects. The first was an exhibition entitled *Contemporary Unknown Painters*, which he organized for the Members' Room of The Museum of Modern Art in 1939. This semiprivate show came on the heels of *Masters of Popular Painting*. There was no catalogue. The second project was his 1942 book, *They Taught Themselves: American Primitive Painters of the 20th Century*. Both the exhibition and the book were restricted entirely to painting; among the better-known artists of the thirty included in them were Anna Mary Robertson ("Grandma") Moses (**FIG. 9**), Morris Hirshfield (**FIG. 10**), Patrick J. Sullivan (**FIG. 11**), John Kane, Joseph Pickett, Patsy Santo, Lawrence Lebduska, Horace Pippin, and Emile Branchard.

In his introductory essay, which concludes under the subheading "In Search of a Name," Janis rejects as acceptable labels for these artists "nonprofessionals," "Sunday painters," "popular painters," "painters of the people," "instinctives," "naives," "primitives," and "naive-primitives." Although it appears in the subtitle, and despite its "very wide application," even "primitives" is "too limited." "Naive-primitives" is unacceptable because of its "undesirable overtones." "Folk artist" will not do because it "implies a person who makes rural or peasant art and directs his efforts to objects made primarily for use." The image of folk art as a nineteenth-century agrarian phenomenon obviously prevented Janis from applying the term to twentieth-century work, just as it did Cahill. Janis would have preferred the term "autodidactic," but because it "is already associated with the sophisticated self-taught among the surrealist painters, who work with full knowledge of the tradition of art," he settles for "self-taught" (Janis 1942, 12–13).

FIG. 9. ANNA MARY ROBERTSON ("GRANDMA") MOSES
In the Maple Sugar Days, 1939 or before, oil on pressed wood, 15 1/4 x 19 1/4 inches, private collection. Photograph © 1973 Grandma Moses Properties, Inc. This Moses painting was one of three included in Sidney Janis's 1939 Museum of Modern Art exhibition, *Contemporary Unknown Painters*.

It is revealing that Janis was tempted to use a term associated with surrealism, for he saw numerous parallels between the interests of the surrealists and the methods of the self-taught artists:

> *With many of the self-taught painters, psychological factors which are tied up with inner conflicts of various kinds are of primary importance. The necessity for working out their psychological problems furnishes one of the mainsprings out of which their pictorial means flow, for through sublimation in paint, they resolve their doubts, their emotions, and their beliefs.*

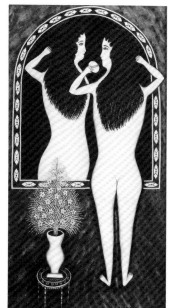

Janis even goes so far as to suggest that their work looks like the work of the surrealists:

> *Knowing nothing of Surrealism, [the self-taught artist] may create enigmatic surface textures, and use literary ideas and fantasies that are closely akin to Surrealism. Knowing nothing of Freud, he may undesignedly employ symbols similar to those Dalí uses with specific intent* (Janis 1942, 10).

He found that the "spiritual innocence" of these artists was expressed with a "humility and an easily comprehended human quality that may be shared by everyone" (Janis 1942, 6–7). Janis praised the work for its representational content and for dealing with human issues, both of which spoke to the common man, as opposed to the expert on modern art.

The Museum of Modern Art's *Masters of Popular Painting* and Janis's *They Taught Themselves* marked the first serious attempts to deal with work that could be called contemporary folk art. Although the organizers of both projects rejected the label and tried to distance the material as far as possible from the category, they described the art in the same terms used by Cahill to define folk art, and referred to the artists themselves as common folk. Cahill had boxed in everyone, including himself, with his definition of American folk art as a preindustrial phenomenon, and by suggesting that painting was not as pure a form of folk art as sculpture.

Despite Cahill's claims about nineteenth-century primitive painting being compromised as folk art, however, no one excluded it from the folk art canon. Exhibitions and books about folk art still present it together with sculpture. It was the twentieth-century self-taught painter who posed the problem of labeling. The twentieth-century artists have the same attributes as their nineteenth-century predecessors: they are self-taught, and share the same identity as common folk making art for common folk. So why were the twentieth-century self-taught painters not seen as folk artists? The answer is only in part because Cahill had defined folk art as a rural product that had stopped being made sometime in the nineteenth century; the greater issue seems to have been the stigma of non-art attached to folk art, which was unacceptable to those championing contemporary popular artists, who all concurred that the work was art.

It is revealing, however, that some of the most popular self-taught painting of the mid-twentieth century could easily have been confused with nineteenth-century painting. The most famous example is the work of "Grandma" Moses, who was included in Janis's 1939 Museum of Modern Art exhibition, *Contemporary Unknown Painters*. In 1940, she had her first one-person show at Otto Kallir's Galerie St. Etienne in New York—one of the few galleries that regularly presented contemporary self-taught painting in the 1940s and 1950s. Joseph Pickett, who was one of Cahill's favorite artists, and Horace Pippin, especially in his interior scenes, conform to a nineteenth-century aesthetic as well. But even if the work resembles the folk art of the preceding century, it cannot be genuine folk art by Cahill's definition. It might be a near relation of sorts—

a first cousin, perhaps—but as far as the art world of the time was concerned, it was not folk art. Instead, it was most commonly called "popular," "naive," "primitive," or "self-taught" painting.

On occasion, contemporary self-taught artists were included in group shows with trained artists, as Cahill informed the reader in the introduction to his 1930 Newark Museum catalogue. But the easiest way to deal with twentieth-century folk art was to avoid labeling it altogether, and this could be done simply by showing individual artists. William Edmondson and Morris Hirshfield, for example, were given small exhibitions without catalogues at The Museum of Modern Art in 1937 and 1943, respectively. Institutions also showcased recently discovered regional talent. The Junior League of Pittsburgh, for example, exhibited John Kane in 1931, and the Isaac Delgado Museum of Art (now the New Orleans Museum of Art) presented Clementine Hunter in 1956.

Gradually, however, the work of the self-taught painters was claimed by the folk art world. By the 1960s, books and exhibitions of nineteenth-century American folk art were generally taking the material into the twentieth century by including the better-known self-taught painters. For example, in their 1966 book *American Folk Art Painting*, Mary Black and Jean Lipman presented mostly eighteenth- and nineteenth-century painters, adding twelve twentieth-century figures, including John Kane, "Grandma" Moses, Clara Williamson, Morris Hirshfield, Horace Pippin, and Joseph Pickett. The work that was selected looked a great deal like the earlier painting, and for the uninformed reader it would be difficult to tell where the nineteenth-century paintings left off and the twentieth-century ones began. The transition from the nineteenth to the twentieth century was virtually seamless.

By the 1960s, twentieth-century self-taught painting had been discovered, digested, and largely absorbed into the folk art world. After all, it could be made to fit many aspects of Cahill's definition of folk art, and much of it looked very nineteenth century. (With the exception of Edmondson's work, sculpture was either overlooked or avoided.) Yet the fine arts world preferred to classify this work as anything but folk art. For most in this camp, it was just art. As had been the case with nineteenth-century folk art, the work of the self-taught painters was appreciated for its strong formal vocabulary. But, fueled in part by the surrealist aesthetic, greater emphasis was now placed on the intense passions and strong individualism embedded in the images—the powerful, personal visions that could be uncannily compelling. All of this work, regardless of the century and despite the claims of some in the folk art world, was no longer just folk art, and had to be distinguished from it in some way. But no suitable tag was coined, and the stage was set for the "term warfare" (Barrett 1986, 4) that erupted in the 1970s.

THE TRIUMPH OF TWENTIETH-CENTURY FOLK ART

The fortunes of twentieth-century folk artists have risen dramatically since 1970. By that time, there was a twentieth century to look back upon—an extensive roster of artists and a vast body of work—and an eye for this material had gradually been developed, especially during the 1960s. At the beginning of that decade, Cahill's notion of American folk art still held sway, but by the end, its dominance was seriously challenged. By 1975, contemporary folk art was beginning to flourish, and a large body of new work was radically changing the way everyone thought about folk art. Since the material was so diverse, it began to stretch the definition of folk art. This sparked a labeling conflict that was much more intense and territorial than the disagreements of the 1930s and 1940s.

FIG. 11. PATRICK J. SULLIVAN
The Fourth Dimension, 1938, oil on canvas,
24 1/4 x 30 1/4 inches, The Museum of Modern
Art, New York, The Sidney and Harriet Janis
Collection. Photograph © 1994, The Museum
of Modern Art, New York.

The history of the Museum of American Folk Art in the 1960s and 1970s reflects the shifts in perception that occurred at that time, with the museum itself playing a central role in bringing them about. It was established in 1961 as the Museum of Early American Folk Art, and the "Early" in the title reflected the founders' belief that the institution should focus on eighteenth- and nineteenth-century material, as did the Abby Aldrich Rockefeller Folk Art Center. The kickoff exhibition in 1962, simply titled *Initial Loan Exhibition* and presented at the Time and Life Exhibition Center in the Time and Life Building, consisted of early Americana, and held no major surprises: awaiting the visitor were decoys, weathervanes, toys, figureheads, and the requisite limner portraits.

In 1964, Mary Black became the museum's director, and despite her long tenure at the Abby Aldrich Rockefeller Art Center as registrar, curator, and director, her programming on occasion deviated from the established norm. In 1964, for example, she mounted *Santos / The Religious Folk Art of New Mexico*. That same year, she appointed as curator Herbert W. Hemphill, Jr., a folk art expert and collector who was a trustee and one of the six founders of the museum.

Shows in 1965 included *Signs of Living Folk Art*, curated by Nina Howell Starr and featuring photographs of twentieth-century roadside signs, and *Folk Carvings by William Edmondson*, an exhibition probably suggested by Adele Earnest and Marian Willard, the latter a dealer and museum trustee who had shown the Nashville sculptor in her New York gallery in 1964. Also presented in 1965 was *The Art of the Carousel*, which was organized by Frederick Fried and contained material that ran well into the twentieth century. One of the four exhibitions in 1967 was *Folk Artists in the City / Painters and Carvers of Greater New York*, assembled by Black and Hemphill and designed to dispel the myth that folk art was solely rural.

The Cahill doctrine of American folk art was destroyed in 1970, as Hemphill took an even greater role in preparing exhibitions. This was the year of his landmark show, *Twentieth Century American Folk Art*. This was

probably the first time anyone had dared do a show of twentieth-century folk art that included *both* painting and sculpture—much of the latter anonymous utilitarian objects—and it provoked an uproar in folk art circles, which included many of the trustees at the Museum of American Folk Art. This exhibition was immediately followed by *Carving for Commerce*, which Hemphill curated with Frederick Fried and which also contained some contemporary material.

In 1971, Hemphill presented a one-person show of a local painter, *Grandpa Weiner*, followed by two more landmark exhibitions, *Macramé* and *Tattoo*, both of which fell well outside the most extreme definition of folk art then in existence, with the result that they set the folk art world on end. For an encore in 1972, Hemphill presented *Hail to the Chief*, an exhibition consisting of election campaign paraphernalia from the nineteenth century to the present. Even more daring was *Occult*, a 1973 show of objects made for supernatural practices, the opening of which was blessed in an invocation rite performed by Brooklyn's Coven of Welsh Traditionalist Witches. *Louisiana Folk Paintings*, a show of contemporary work by Sister Gertrude Morgan, Bruce Brice, and Clementine Hunter, which was curated by William Fagaly several months later, must have come as a welcome relief to the conservative faction of the folk art world. Ten years earlier, it would have raised eyebrows.

Hemphill's definition of folk art was as inclusive as Cahill's was exclusive. This became clear as early as 1970, in the show *Twentieth-Century American Folk Art*. There was no catalogue or checklist for the exhibition, but

FIG. 12. EDDIE ARNING
Interior with Figures, 1969, crayon on wove paper, 22 x 28 1/8 inches, National Museum of American Art, Smithsonian Institution, Gift of Herbert Waide Hemphill, Jr., and Museum Purchase made possible by Ralph Cross Johnson, 1986.65.164.

in 1974 Hemphill and Julia Weissman, a writer with a strong interest in folk art, published *Twentieth-Century American Folk Art and Artists*, a book based on the exhibition, with much more material added. In the introduction, Weissman described the exhibition:

> *In addition to pictorial modes, the exhibition included wood carvings that ranged from Edgar Tolson's stark, whittled figures to the more detailed* santos *of latter-day New Mexican religious tradition, naive neon and ebullient road signs, toys and decoys, astonishing pieces done with fabric and needle skills, assemblage objects built of collectors' mania and memorabilia, and photographs showing examples of storefront art, graveyard art, scarecrows, fantasy gardens, and environments* (Hemphill and Weissman 1974, 8).

Among the more recently discovered artists included in the show were Eddie Arning (**FIG. 12**), Vestie Davis, Minnie Evans, Victor Joseph Gatto, Theora Hamblett, Clementine Hunter, J. C. Huntington, Justin McCarthy, Sister Gertrude Morgan, Jack Savitsky, Dana Smith, Edgar Tolson, and Joseph Yoakum. There was an enormous amount of anonymous material, including "Appalachian broom dolls, an articulated doll impersonating Bing Crosby [**FIG. 13**], a Mickey Mouse kachina, duck decoys, New Mexican *bultos*, and a neon fish trade sign from the 1930s" (Hartigan 1990, 31).

The exhibition seemed to include every imaginable kind of object, both two- and three-dimensional, which dealt with an endless range of themes, issues, and motifs. Craft, popular culture, and art were all present in Hemphill's mix. The material was not displayed within any hierarchy of importance. Nor was it organized according to type, such as toys, decoys, trade signs, or painting. The installation itself was rich and dense to the point of clutter. The show was not only a feast for the eyes, but also food for thought: it clearly stated that there was a wealth of contemporary folk art being produced, and that it came in many guises.

The introduction to *Twentieth-Century American Folk Art and Artists* makes it clear that the authors considered all of the work to be folk art, including paintings by Hirschfield and Sullivan that Cahill and Janis had definitely declared not folk art. After rejecting numerous terms, including "naive," "popular," "amateur," "grassroots," "compulsive," "spontaneous," and "unconscious," Weissman defines folk art as "truly the art of the people, by the people, and for the people" (Hemphill and Weissman 1974, 10). It consists of

> *the works of truly American folk; everyday people out of ordinary life, city and suburban, small town and country folk, who are generally unaware of and most certainly unaffected by the mainstream of professional art— its trained artists, trends, intentions, theories, and developments* (Hemphill and Weissman 1974, 9).

Although it might look radically different, Hemphill and Weissman found that twentieth-century folk art was fundamentally the same as eighteenth- and nineteenth-century folk art (**FIG. 14**). Like Cahill, they view the work as coming out of craft traditions, with the art resulting from "the bending of tradition to serve a personal vision." The contemporary work shares with the historical work a timelessness of vision and a constant reinvention of technique that allow for "the unhindered primacy of their statements." The importance of the work is that it partakes not of the world of art but of the "organic nature of things"—a quote taken from Herbert Read to refer to the way in which artists are inspired by their immediate environments. This is "a more accessible and comprehensible art" that meets immediate human needs and feelings—the artists are the "journalists of the human condition" (Hemphill and Weissman 1974, 11). It is remarkable that this definition of twentieth-century folk art hardly varies from Cahill's definition of nineteenth-century folk

art, or from his appreciation of what he called "twentieth-century popular masters."

Cahill's image of American folk art was thus replaced with a new one that could accommodate a broad range of material, made at any time and any place. This is not to say that many in the folk art world did not continue to admire and emphasize nineteenth-century Americana, which in the 1970s was perceived very much as it had been in the 1930s. But the new wealth of twentieth-century material projected an image quite different from that of the "old" folk art.

America was ready for the "new" folk art that Hemphill was promoting. The world to which Cahill belonged may have preferred to retreat to the Jeffersonian past, but the generation of the Eisenhower/Kennedy/Johnson era embraced the American present. The United States emerged from World War II as a financial and military leader, and Americans were proud to be American. A robust economy turned the United States into a nation of consumers dedicated to acquiring modern, high-tech appliances and products made in the U.S.A. This wave of materialism, and the marketing that accompanied it, was in part celebrated in pop art.

Out of this environment, a new wave of collectors emerged, not only for American art but also for American collectibles—material ranging from cookie jars to carousel horses, nickelodeons, and commercial signs. The worlds of popular art and folk art soon began to overlap, becoming indistinguishable to some. Andy Warhol's

personal collection, begun in the 1950s and exhibited at the Museum of American Folk Art in 1977, epitomized the new love of contemporary Americana: it included exceptional examples of fine and decorative

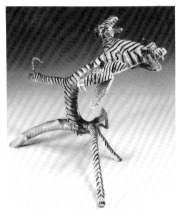

arts, but it was dominated by contemporary vernacular objects, including trade signs, logos, architectural ornaments, pinball machines, carousel carvings, nickelodeons, and cookie jars. Frederick Fried, an art director at Bonwit Teller's in the 1950s and early 1960s, collected contemporary Americana as well, and probably influenced the collecting habits of Warhol, who worked with him at the department store, and of Hemphill. Fried had a special passion for carousels. In 1964, he published a *Pictorial History of the Carousel*, besides mounting the exhibition at the Museum of American Folk Art (Hartigan 1990, 24–50).

The growing interest in American vernacular objects was reflected in Ronald G. Carraher's 1970 book *Artists in Spite of Art*, which consisted of illustrations of road and store signs, field figures such as scarecrows, outdoor Christmas sculpture, roadside peace symbols, car trinkets, decorated cars, rubber-stamp designs, personalized mailboxes, fraternal symbols and crests, and tattoos. Not convinced that all of this material was art, Carraher simply labeled it "naive art," claiming that his illustrations "document some of the ways people have satisfied their need for creative self-expression" (Carraher 1970, 7).

In addition to a love of everything American, interest in contemporary folk art was fueled by the liberal tenor of the era. The twenty-year period from 1955 to 1975 accounted for the beat generation, the civil rights and feminist movements, and the "peace and love" generation. There was a broadening of horizons, interests, and tolerance, and a growing taste for the offbeat and unusual. Fine art reflected the shift with an anything-goes attitude: by the mid-1960s, artists began exploring new media and artistic formats, from environmental and site-specific works to objects made of unorthodox non-art materials. The detritus of contemporary society became the bricks and mortar of the new art. Performance art, installation art, video art, word art, conceptual art, earth art, and site-specific art challenged old-fashioned canvas painting and welded-steel sculpture for dominance of the art world. By the early 1970s, narrative, figuration, and representation were rivaling abstraction as respectable formats in which to work, and political and social issues were considered fair

FIG. 14. MILES CARPENTER
Root Monster, 1968, carved and painted tree roots, rubber, metal, and string, 22 5/8 x 28 5/8 x 28 1/4 inches, National Museum of American Art, Smithsonian Institution, Gift of Herbert Waide Hemphill, Jr., and Museum Purchase made possible by Ralph Cross Johnson, 1986.65.238.

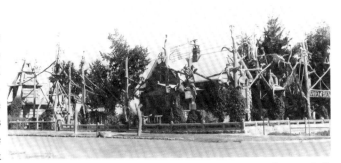

content for art (Hartigan 1990, 24–50).

The new climate was especially receptive to the work of untrained artists, who were adventuresome in their use of media and whose work was for the most part representational, often having a strong narrative component. Unsurprisingly, schooled artists played a leading role in developing a taste for their work, just as they had done for folk art in the beginning of the century. Warhol was a painter, Frederick Fried was an art director, and Hemphill had trained as an artist at Bard College. Michael Hall was a sculptor teaching at the University of Kentucky in 1968 when he and his wife, Julie, met Hemphill at the Museum of American Folk Art and became fanatical about the material. Over the next ten years, the couple discovered dozens of contemporary self-taught artists, amassed a world-famous collection of nineteenth- and twentieth-century folk art, and was instrumental in presenting exhibitions.

The Florida artist Jim Roche befriended and promoted such untrained artists as "Texas Kid" Watson, W. D. Rice, and Jesse James Aaron. Several major artists were unearthed in rural Pennsylvania by the art educators Sterling and Dorothy Strauser of East Stroudsburg. They had discovered Victor Joseph Gatto while visiting country fairs in the 1940s, and among their finds in the 1960s were Justin McCarthy and Jack Savitsky; McCarthy was included in the 1966–67 Museum of Modern Art circulating exhibition *Seventeen Naive Painters*, and both Savitsky and McCarthy were selected for Virginia Zabriskie's 1969 exhibition *American Naive Painting: Twentieth Century*.

Chicago artists made a dramatic contribution to folk art awareness. While working as a visiting instructor at Sacramento State College in 1968, Jim Nutt discovered Martin Ramirez, and arranged for an exhibition of his work at the school. In 1971, with his wife, Gladys Nilsson, and the Chicago art dealer Phyllis Kind, he acquired hundreds of Ramirez drawings from Dr. Tarmo Pasto, a psychologist who had saved the fragile works on paper made from 1948 to 1960 while the artist was institutionalized for schizophrenia. Nutt and Nilsson also began collecting the drawings of the Chicago artist Joseph Yoakum in 1968. Other Chicago artists, among them Roger Brown, Cynthia Carlson, Ray Yoshida, Christina Ramberg, and Barbara Rossi, also acquired Yoakum's drawings. By 1973, Phyllis Kind, who specialized in Chicago artists, especially the Chicago imagists, was showing Ramirez and Yoakum as well. During the 1970s she added P. M. Wentworth, Henry Darger, Malcah Zeldis, Howard Finster, Eddie Arning, Elijah Pierce, Miles Carpenter, Drossos Skyllas, Minnie Evans, Steve Ashby, Edgar Tolson, and Mary Borkowski to her roster of twentieth-century untrained artists, making hers one of the very few galleries to specialize in contemporary self-taught art at this time, and establishing Chicago as a major center for this material.

The other major center for contemporary folk art was Philadelphia, which was closely allied with Chicago in the early 1970s. Italo Scanga, a Philadelphia sculptor, began collecting Yoakum's drawings after visiting a 1970 exhibition of his work at the Museum of Art at Pennsylvania State University in College Park. The artists Cynthia Carlson, Rafael Ferrer, and Ree Morton, all of whom had strong ties to Chicago and were teaching at the Philadelphia College of Art in the early 1970s, spread their excitement about Ramirez and Yoakum to the local art community. The Janet Fleisher Gallery, directed by John Ollman, participated in this enthusiasm by occasionally showing contemporary untrained artists. In 1971, the gallery presented a one-person exhibition of Sister Gertrude Morgan. In the mid- to late seventies, work by Yoakum, Ramirez, Finster, Frank Jones, and Inez Nathaniel-Walker passed through the gallery.

Between 1960 and 1974, more than two hundred self-taught artists were discovered; a folk art fever every bit as heated as that of the 1920s and 1930s had caught hold. Stories abound of extensive road trips to the four corners of the United States in search of work, with Hemphill often figuring prominently in them. A love of the material drove this group of collectors, and for the most part they were not much concerned with labeling it. Hemphill and the Halls, at least in the early seventies, called it "folk art." Most artists and dealers simply considered the work art. They appreciated it for its highly personal visions and for the uniqueness of the artistic vocabulary that each artist developed.

Labeling became an issue when the material was published or put into a museum context. The work was not always considered folk art outside of institutions dedicated to that field. For example, the artist Gregg Blasdel titled his 1968 *Art in America* article on folk environments "Grass-Roots Artist." The article presented photographs the author had taken of fifteen visionary monuments scattered throughout the United States. Among the works pictured were Simon Rodia's Watts Tower in Los Angeles; S. J. Dinsmoor's Garden of Eden in Lucas, Kansas (**FIG. 15**); Jesse Howard's signs in Fulton, Missouri; Fred Smith's Concrete Park in Phillips, Wisconsin; and Clarence Schmidt's House of Mirrors in Woodstock, New York (**FIG. 16**). Blasdel, like everyone who had come before him, felt both compelled and at a loss to categorize the work. He apologized for using "grass roots," a term that he felt was ineffectual but nonetheless preferable to "primitive," "folk," and "naive," since it placed its makers among the common man and outside of the art community (Blasdel 1968, 24–25). This is exactly how Cahill had defined folk art, but Blasdel was not coming to the work from a folk art perspective. He may have found the work too idiosyncratic to fit into the folk art mold; there was too much art and not enough of the community in it. While emphasizing that each artist was self-taught and "unaware

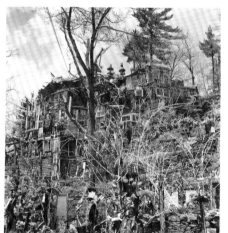

that he is an artist," Blasdel pointed out that the work had strong parallels to other contemporary art:

> The continuous patterns, geometric shapes and symmetrical compositions are at times suggestive of the products of the hard-edge and pop schools, and the choice of objects and materials as well as the attitude of total involvement is comparable to that of contemporary artists concerned with assemblage, environments, happenings and light art (Blasdel 1968, 25).

Blasdel's photographs became the foundation for a 1974 exhibition at the Walker Art Center, *Naives and Visionaries*. Again, the work was being looked at in a non–folk art context and the term "folk art" was rejected. Martin Friedman, the director of the Walker Art Center and an expert on contemporary art, claimed in his introduction to the catalogue that "the hand-made universes created by elderly individualists" are definitely not folk art, although "it may be convenient to characterize these architectural manifestations" as such. Friedman considered folk art to be a collective, not an individualistic, expression. Despite their estrangement from the art world, the work of the artists in this show seemed to him to parallel the direction other contemporary art was taking. He avoided labeling, referring to the makers simply as "artists" (Friedman 1974, 7).

Labeling was further complicated with the publication of Roger Cardinal's 1972 book *Outsider Art*. Writing in Great Britain, Cardinal was strictly oriented toward Europe, not acknowledging—and at that time probably unaware of—the American artists then being discovered. His book was essentially about Jean Dubuffet's collection of work by untrained artists, work that the French artist had first encountered in 1945 and labeled *art brut* shortly thereafter. Cardinal was especially influenced by a 1967 exhibition of this material at the Musée des Arts Décoratifs, and by Dubuffet's catalogue essay, "Place à l'incivisme" ("Make Way for Barbarism").

FIG. 16. CLARENCE SCHMIDT
House of Mirrors, 1964–67, Woodstock,
New York. Photograph © Gregg N. Blasdel.

Following surrealist theories, Dubuffet claims that civilization, which is controlled by a small elite, hinders the creative impulse: operating within restrictive cultural values as they self-consciously play to a specific audience, trained artists are unable to tap into the innermost self to express basic emotions, needs, and concerns. An unselfconscious artist must be unaware of cultural values, not thinking of his or her work as art or making it for an art audience. The most likely candidates to meet these criteria were the insane, and Dubuffet collected their work. He also accepted into his *art brut* world mediums and innocents, the latter defined basically as recluses virtually unaware of civilization.

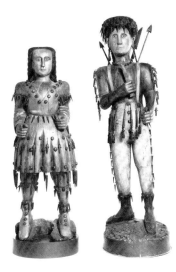

Cardinal became an advocate of Dubuffet's *art brut*, which he called "outsider art" and distinguished from folk and naive art. While folk art could be produced in remote regions, far from mainstream culture, it was nonetheless subject to tradition; it was not made in a cultural vacuum, as was outsider art. "Naive artists" might not have academic or technical training, but might still be aware of fine art, to the point of aspiring to be "colleagues of professionals" (Cardinal 1972, 35); Cardinal places Henri Rousseau and Morris Hirshfield in this category. True "outsider" art must be produced in isolation, basically for oneself, with no awareness of cultural values. He concludes by claiming that the key feature of this work is not the finished product per se, but the creative process itself—"the psychic energy that went into the making of the piece, which imbues the art with an intensity not found in the art of the trained artist" (Cardinal 1972, 53). Like Dubuffet, Cardinal implies that this quality makes outsider art more original, and perhaps more valid, than fine art.

Cardinal's theories about the psychic energy of outsider art had little immediate impact in America, but his concept of the artist working in relative isolation and creating unique work gradually became an issue. The word "outsider" crept into the folk art vocabulary, although with a different meaning from that used by Cardinal. The idea that a folk artist could be someone working on the fringes of society, as opposed to being the anonymous common man embodying community values, began to gain credence. For example, in 1976 Herbert Hemphill organized an exhibition for The Brooklyn Museum and the Los Angeles County Museum of Art called *Folk Sculpture USA*, which showed works from the eighteenth century to the present, including unusual and difficult pre-twentieth-century work that did not conform to the charming, quaint image the public had of early folk material (**FIG. 17**). This in effect seriously challenged conventional perceptions of the earlier period, as well as demonstrating that new work was part of an ongoing tradition. In the catalogue, he describes specific works as having an "almost surreal quality" and an "almost frightening intensity." Instead of epitomizing a homogeneous American spirit, these artists are "outside the mainstream of American life, *outsiders* who are free from the dogmas and restrictions that the dominant culture (and its academic art world) imposes" (Hemphill 1976, 8; emphasis added).

Folk Sculpture USA was an important exhibition, reinforcing a growing appreciation of folk artists who were somewhat quirky—nonconformists who went a bit beyond the norm. At the same time, the more the self-taught artist was viewed as an eccentric working on the fringes of the community, the harder it became to consider him or her a folk artist with roots in the surrounding society—the common man making art for the common man.

Hemphill always considered work such as that in *Folk Sculpture USA* to be the product of folk artists, regardless of how unusual it might be, and he always described it as art, never feeling compelled to declare that it

FIG. 18. WILLIAM BLAYNEY
The Four Winds of Heaven, 1960, oil on
Masonite, 24 x 31 1/2 inches, collection of
David T. Owsley.

was either inferior or superior to fine art. His position was opposed by Daniel Robbins, an art historian specializing in twentieth-century art who unequivocally declared in his catalogue essay that folk art was not art, and that it was inferior to art. If an object was not consciously made as art with an awareness of the values and vocabulary of the art world, then it belonged to the world of artifact and material culture, and its study was the province of anthropologists and folklorists. It should be viewed within the proper social and historical context, and not simply be appreciated for its formal qualities, or treated as though it were merely a found object onto which viewers could impose personal needs and aesthetics. In contrast to Hemphill,

for whom folk art was alive and well, Robbins, like Cahill before him, wished to assign it a death date, claiming that folk art could not exist after 1950. By then, he asserted, the mass media had invaded the most remote areas of American society, making it impossible for anyone to be naive about art (Robbins 1976). Conceived as a celebration of American folk sculpture in honor of the Bicentennial, *Folk Sculpture USA* became a battlefield for opposing forces struggling to label and qualify its contents.

Almost invariably, folk art shows before the 1970s had presented the material as art objects, to the great displeasure of folklorists and scholars of material culture, many of whom, like Robbins, called for putting folk art into a meaningful social and cultural context, rather than treating it as art. If folk art is art made within a community for the community, then what is that community about, and how are its values reflected in the art? What is the "folk" in folk art?

This failure to put the work into context was attacked in the 1970s. Perhaps the most dramatic challenge came from the historian and folklorist Kenneth Ames. In the venue of an exhibition and catalogue titled *Beyond Necessity: Art in the Folk Tradition*, which he organized in 1977 from the collections of the Henry Francis du Pont Winterthur Museum for the Brandywine River Museum, and, later the same year, at a three-day conference on American folk art held at the Winterthur Museum, Ames railed against a host of ills that plagued folk art scholarship. Principally, he objected to viewing folk art as art and subjecting it to the criteria reserved for high art, since emphasizing the formal properties of the work inevitably resulted in losing the human components. He complained about "object fetishism," by which he meant unqualified praise for the work's aesthetic beauty, and about "creator worship," or preoccupation with biography for biography's sake. He also objected to the emphasis the discipline placed on "primacy," or historical firsts, and attacked the use of "evaluation," or the qualitative measuring of objects. By categorizing folk art as art, scholars were establishing a value system that doomed folk art to failure: fine art would always appear to be superior.

To rectify this one-sided scholarship, Ames called for what he would later describe as "centrifugal patterns of inquiry," "which can build bridges [from the object and artist] to other disciplines and help create a broader and more thorough understanding of human beings" (Ames 1980, 320). Taking his cue from Michael Owen Jones, another Winterthur symposium participant and folklorist, Ames advocated dispensing with labels entirely, including "folk art" and "fine art," along with concepts of style and period, and replacing them with his own concept of "human behavior" (Ames 1980; Jones 1980).

In calling for the removal of labels altogether, Ames represents an extreme position. Other folklorists advocated the contrary. For example, in a 1986 article, "The Need for Plain Talk about Folk Art," John M. Vlach argues that it is essential to employ rigid definitions for any terms used, and complains about expanding the definition of folk art to the point where it becomes worthless. He emphasizes the importance of starting any study of folk art by researching the artist's intentions and social behavior. This research would naturally lead

to, among other things, the art, which is a product of the social context. In spite of the disagreement about using definitions, however, Vlach is ultimately not so far apart from Ames, since he also calls for putting the work into a proper context and objects to comparisons of folk art with fine art and to the use of the language of fine art to evaluate folk art.

As the 1970s drew to a close, the work of twentieth-century untrained artists was quickly mounting in popularity. More and more material, both paintings and sculpture, some anonymous, some not, was thrown into the kitchen sink of "folk art," by both folk art and fine arts institutions. But there were many outside of the folk art world who, like Cahill, Barr, and Janis in the 1930s, continued to argue that some of this material was neither folk art nor cultural artifact; instead, it was "art." Paintings especially were perceived as full-blown art objects, although there was always the need to modify the term "art" somehow, with qualifiers like "self-taught," "naive," or "visionary." There was still no agreement on a label.

In the 1980s, the interest in work by nonacademic artists that was "pure" art began to gain momentum. On March 6, 1981, a landmark exhibition opened at the Philadelphia College of Art. Entitled *Transmitters: The Isolate Artist in America*, it was the first American exhibition of twentieth-century self-taught art that was restricted entirely to painting, drawing, and sculpture, and contained no material that could easily be described as utilitarian or craft. The twenty-five artists in the exhibition included William Blayney (**FIG. 18**), Miles Carpenter, Henry Darger (**FIG. 19**), William Edmondson, Howard Finster, Morris Hirshfield, Jesse Howard, Inez Nathaniel-Walker, John Perates, Elijah Pierce, Martin Ramirez, Drossos Skyllas, Mose Tolliver, Edgar Tolson, P. M. Wentworth, and Joseph Yoakum. The mix of artists includes "Sunday painters" like Hirshfield and Skyllas, who worked on stretched canvases and aspired to be "colleagues of professionals." Most, however, like Tolliver, Finster, and Yoakum, were artists who work on inferior or even found material and cultivate abstract, expressionistic styles that are redolent of high art without intending to be so.

The curator was Elsa Weiner Longhauser, then director of exhibitions at the college and now director of the gallery at the Moore College of Art; her interest in self-taught art dates back to the 1960s. In her catalogue introduction, she labels the artists "isolates"—"persons whose lives had isolated them from sophisticated art movements or traditions." "What struck me most about this work was not only its artistic power and strange beauty but also its creators' innate sense of form, color, and design," she continues. While so far this language sounds much like that of Holger Cahill and Bert Hemphill, she parts company with them when she ends her brief introduction by suggesting that the work conforms to Roger Cardinal's concept of "outsider art": "Although European Isolates, known as Outsiders, have received recognition and critical attention abroad, their American counterparts have received only minimal attention" (Weiner 1981). Here is a strong suggestion that these artists are psychologically focused to the point of blocking out cultural influences. It probably represents the first application of Cardinal's definition to American art presented in an American context (Cardinal himself had included Darger, Ramirez, and Yoakum in a 1979 London exhibition called *Outsider Art*, which was mounted at the Hayward Gallery); it is questionable, however, whether Cardinal himself would have considered all of the work in *Transmitters* outsider art.

The title for the Philadelphia exhibition, and the term "isolate," come from Michael and Julie Hall, whose

FIG. 19. HENRY DARGER
Draw Drops of Water, n. d., watercolor, pencil, and collage on paper, 24 x 54 inches, collection of Yosi Barzilai. Photograph courtesy of Phyllis Kind Gallery, New York.

FIG. 20. BILL TRAYLOR
Untitled (Man and Large Dog),
ca. 1939–42, poster paint on card-
board, 28 x 22 inches, courtesy of
Luise Ross Gallery, New York.

contribution to the catalogue takes the form of a dialogue about the works in the show. They never define "isolate art," other than to say that the label refers to "some specific isolation of the person of the artist [that] can be sensed in all of the creative oeuvres assembled here." They claim that examples of isolate art can be found in folk, self-taught, and outsider or visionary art, all of which is included in *Transmitters*. Despite their emphasis on the isolation of the artists, the Halls stress that no art, no matter how visionary, "is untouched by culture. All art, even the art of the insane, does not come from or go to anywhere that somebody else has not visited" (Hall and Hall 1981, 9). In other words, isolate art incorporates a balance of the individual and the community.

Marcia Tucker's preface to the catalogue reflects the period's reluc-tance to agree on any terminology for the work in the exhibition. Tucker, the director of the New Museum of Contemporary Art, calls the artists "folk artists," not "isolates" or "outsiders." While she agrees that most of the artists work in isolation, some to the point that they "will not show their work even to their own families," she emphasizes that the artists are nonetheless part and parcel of a community, which is reflected to some degree in their work (Tucker 1981, 4).

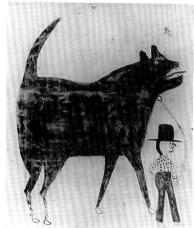

In a fourth contribution to the catalogue, an essay entitled "Ecstasy and the Doodle," Richard Flood, an expert on contemporary art, rejects "folk art" as a term to describe the work in the exhibition. It is inadequate because the show's

> *fantastical imagery is psychologically aggressive, while in folk art the content is, by definition, the expres-sion of a kindred consciousness....The art in this exhibition, however, comes from no collective impulse; it is arro-gantly solipsistic in origin* (Flood 1981, 5).

Flood also rejects the term "outsider," which he finds too "capricious." Nonetheless, his essay shows a great deal of interest in the psychological presence of the artist in the work, and he even suggests that isolate art embodies the personal essence of its maker. In effect, Flood suggests that this is one quality that distinguishes it from fine art. He writes:

> *It is dangerously easy to over-dramatize the character of the isolate artist. Yet, it would be foolish to overlook the extreme, often melodramatic nature of the work. Isolate art does not rest easily on a sculpture pedestal or insou-ciantly hug a gallery wall. It is too itchy, too raw and frictional to be comfortably decorative. The best of it is almost embarrassingly personal and tells us more than we may enjoy knowing about the sincerity of its maker. Because its aesthetics are so often in contradiction to the norm, much of the work can appear startlingly fetishistic—as though it offered the artist a means of catharsis rather than an avenue for aesthetic expression.*

At this point, Flood announces that he is reluctant to develop this line of thought any further, for fear that emphasizing the psychological presence of the artist in the work will detract from an appreciation of its formal or aesthetic components, which are what Flood seems to admire most. To use his own words, "Such analysis can result in a pathologic aesthetic as wrongheaded as it is seductive, but to turn one's back on the biography is to miss a wealth of poetic mystery" (Flood 1981, 6).

Transmitters was an important exhibition because it represented the first introduction of Cardinal's theories about outsider art to an American audience. Only Elsa Weiner Longhauser, however, was willing to accept the term; the rest of the catalogue's writers modified it by introducing a strong cultural component into their discussion of the art even while retaining the concept of artistic isolation and, by implication, a strong

psychological component. The show was also important because it represented the work as art—and, in the case of the living artists, as contemporary art at that. Marcia Tucker recommended that trained artists look to these artists as an example, and base their own work on strong, powerful emotions that stem from a response to the immediate environment. *Transmitters* did not tour. It closed quietly in Philadelphia, and the label "isolate," which none of the authors ever specifically defined, never entered the vocabulary used for this material.

An exhibition that had a dramatic impact was Jane Livingston and John Beardsley's *Black Folk Art in America, 1930–1980*. The show opened in 1982 at the Corcoran Art Gallery in Washington, D.C., and toured to Los Angeles, New York City, Houston, Louisville, Detroit, and Birmingham, Alabama. Like *Transmitters*, which was being organized at approximately the same time, it was limited to work that could be considered painting, drawing, or sculpture. The work was by twenty African-American artists, most of whom were from the South: among them were Jesse Aaron, David Butler, Sam Doyle, William Edmondson, James Hampton, Sister Gertrude Morgan, Elijah Pierce, Nellie Mae Rowe, Mose Tolliver, Bill Traylor (**FIG 20**), and Joseph Yoakum (**FIG 21**). None of these artists was a "Sunday painter"; instead of working on stretched canvases, many made their work on found materials. Most of the two-dimensional artists had an expressionist style that was extremely flat and abstract. The exhibition hammered home the fact that an inordinate amount of the best art by twentieth-century untrained artists was made by African-Americans.

In her introductory essay, "What it is," Livingston made a point of letting her readers know that the show was strictly art. The work "has to do not with crafts or traditional utilitarian artisanship, but with full-fledged gratuitous art objects, paintings and drawings and sculpture." Like Cahill and virtually everyone who came before her, Livingston found that the attraction of the work stemmed in part from the formal qualities: "The artists working in this esthetic territory are generally untutored yet masterfully adept, displaying a grasp of formal issues so consistent and so formidable that it can be neither unselfconscious nor accidentally achieved" (Livingston 1982, 11). She especially admired the cultivated crudeness that she felt was shared by most if not all of the artists in the exhibition:

> *And yet there is the overarching atmosphere of a single tradition, even of a single style. It is an esthetic which seems to understand the beauty which inheres in intentional crudeness or indecorum; at times it assertively denies "the beautiful." It is in great measure an esthetic of compassionate ugliness and honesty* (Livingston 1982, 13).

To prove her claim, and to account in part for the raw, crude style and for the difference between folk art and fine art, she goes on to say:

> *The difference between the academic and the self-taught artist is that often as the latter becomes more proficient and complex, he becomes more raw, apparently more clumsy and bold and uninhibitedly prolific; the schooled artist, in contrast, generally becomes more refined and subtle and technically proficient.... Recent attempts to further our understanding of the difference between folk art and "high art" emphasize a kind of unification between the self and object in the folk esthetic, an overcoming of the alienation of the artist from the world through art.... The folk artist, unlike the self-conscious, dialectically engaged one, views his own artifacts as being inseparable from life itself, as being a kind of recreation of his experience* (Livingston 1982, 16; emphasis added).

Livingston does not build further on this statement. Like the writers for *Transmitters*, she points out that most of the artists in the exhibition work in relative isolation. But she stresses that their work is nonetheless a reflection of their immediate communities and the values of contemporary society, and while she approaches the painting and sculpture in her exhibition as art, pure and simple, she is willing to call it folk art—although her use of the term suggests that it has been chosen for the sake of convenience, in the absence of a better alternative.

Black Folk Art in America strengthened an interest in work that was pure painting and sculpture, but it clouded the waters for labeling, since Livingston put back material that Elsa Weiner Longhauser had removed from the folk art category. Until this problem got solved, there was no agreement on what to do with the twentieth-century work. The plight of twentieth-century folk art was recapped by Didi Barrett in her 1986

Museum of American Folk Art exhibition at the Paine Webber Gallery, *Muffled Voices: Folk Artists in Contemporary America*, one of the few other high-profile exhibitions in the 1980s of pure painting, drawing, and sculpture in this tradition that did not have a regional or tight ethnic focus. In her introductory catalogue essay, she presents the work as an art world orphan:

> *There exists here an extraordinary body of art—bold, complex, expressive, obsessive, and visionary—which represents the mating of the modern and the folk. Yet prior to this exhibition, these contemporary artists and their work had been eschewed by virtually all the established art communities. The traditional folk art establishment, asserting that folk art ended with the nineteenth century, has refused to acknowledge twentieth century folk artists. Most modernist critics have ignored their work since it does not follow a particular artistic school. And the folklorists snub them because their art does not grow out of a communal tradition. Theirs are the muffled voices of contemporary American art* (Barrett 1986, 4).

In the nine years since *Muffled Voices*, nothing has changed. There have been numerous exhibitions and publications devoted to "pure" art by twentieth-century untrained artists, and the confusion about how to classify the material persists. "Folk," "self-taught," and "outsider art" are the preferred terms used to describe what is often exactly the same material, although the literature is filled with other labels.

Established folk art centers such as the Museum of American Folk Art and the Abby Aldrich Rockefeller Folk Art Center, along with some fine arts museums such as the Milwaukee Art Museum, continue to use the term "folk art." Those who feel that "folk art" is too closely associated with crafts and utilitarian objects prefer the term "self-taught" when referring to painting, drawing, and sculpture. The New York dealers Roger Ricco and Frank Maresca used this term for the title of their 1993 book, *American Self-Taught*, on the ground that it is the most neutral of the options. However, to reflect the prevalent use of "outsider artist" and to be more inclusive, the authors subtitled the book *Paintings and Drawings by Outsider Artists*. "Self-taught" was also preferred by Alice Rae Yelen for the subtitle of *Passionate Visions of the American South: Self-Taught Artists from 1940 to the Present*, an exhibition and catalogue organized by the New Orleans Museum of Art in 1993 that focused on artists and issues particular to the South.

Others prefer the label "outsider" for all untrained artists. Roger Manley and David Steel used it for their 1989 North Carolina Museum of Art exhibition, *Signs and Wonders: Outsider Art Inside North Carolina*, although in Steel's introduction and Manley's essay in the catalogue they seem to broaden the definition of "outsider" to mean "art by ordinary individuals who are not part of the art world" (Steel 1989, ix)—a definition that does not distinguish outsider from folk art. The Outsider Art Fair, an annual New York art show inaugurated by Sanford L. Smith in January, 1992, presents work that can be described as painting, drawing, and sculpture (there are no utilitarian objects); the title undoubtedly refers in part to the media, but is also used as the antithesis of "insider," as a way to declare that the artists are working outside of a high art context.

In 1994, Michael D. Hall and Eugene W. Metcalf, Jr., published a collection of essays entitled *The Artist Outsider: Creativity and the Boundaries of Culture*. The essays in this book debate a range of issues that have swirled around the folk art world. One essay that makes a stab at defining outsider art is "Toward an Outsider

Aesthetic," by Roger Cardinal (Cardinal 1994a). As in his 1972 book *Outsider Art* and his 1979 Hayward Gallery exhibition *Outsiders*, Cardinal emphasizes the work's lack of "artistic antecedents" and the way it "comes into being through an intense investment of the private self"; outsider art is a "documentation of subjectivity." While the book *Outsider Art* reflects Dubuffet's initial collecting emphasis of work by institutionalized artists, Cardinal's concept of the outsider goes well beyond this limited group, as did Dubuffet's eventually. But it is not clear how far he has broadened the definition, unless he considers as outsider art all work that does not fall into the categories of folk and naive art as he defines them. In a recent article, "The Self in Self-Taught Art," published in *Art Papers* (Cardinal 1994b), Cardinal defines self-taught art in the same terms he used for outsider art, even on occasion interchanging the label "contemporary folk art" with "self-taught art." But if Cardinal is not precise about isolating the boundaries of outsider art, he has succeeded at identifying its core—the powerful presence of the artist's self in the work.

The concept of outsider art was also the focus of the catalogue accompanying a European exhibition, *Outsider USA*, which was organized by Thord Thordeman as part of an international folk art show at the Malmö Konsthall in Sweden in 1991. *Outsider USA*, which split off from the main exhibition and toured Europe, featured American artists only, including Bill Traylor, Martin Ramirez, Mose Tolliver (**FIG. 22**), P. M. Wentworth, the "Philadelphia Wireman," Eugene Von Bruenchenhein, and Minnie Evans. The art was limited to painting, drawing, and sculpture, following the trend established in the 1980s. In his introduction to the catalogue, Thordeman posits outsider art, which he defines in the broadest sense of the term as a catch-all for untrained artists, as the new avant-garde, claiming that modernism is dead and that post-modernism simply "seems like variations on a theme." But outsider art, because of its highly individualistic nature, is always new. While the term "outsider art" is used at present to "market" this art, he says, it will eventually be dropped, as the art is "absorbed" into contemporary art (Thordeman 1991, 9). Many in the art world had argued that folk art should be considered art—Alfred Barr in 1938, Martin Friedman in 1974, and Elsa Weiner Longhauser in 1981—but this statement by a non-American is perhaps the strongest to date, since it insists that the work is not only art, but avant-garde art.

The catalogue included four essays, all by Americans and all taking somewhat different positions on the content of the exhibition. Of special interest for its insights into outsider art is John MacGregor's essay, "Altered States—Altered Worlds." More than any other American writer to date, this art historian, trained at Princeton University and author of *The Discovery of the Art of the Insane* (Princeton University Press, 1989), operates out of Dubuffet's most restrictive premises and argues that the outsider artist is someone who creates images and objects from deep within the psyche, well beyond the level that can be accounted for simply "by sociological and cultural explanation" (MacGregor 1991, 11). Cultural and historical signs are assigned minimal significance: "While the slight historical and cultural influences invariably present in all Outsider works usually provide an indication of the origin of a given work in time and place, the overwhelming individuality and intense subjectivity fundamental to the nature of this art makes consideration of such external influences all but meaningless" (MacGregor 1991, 10).

In fact, MacGregor criticizes Americans for ignoring or misrepresenting the concept of outsider art by using the term to mean simply "a position outside of the 'artistic mainstream'," or by using "outsider" interchangeably with categories like "folk art" and "naive painting." Why are Americans so reluctant to embrace the concept

FIG. 22. MOSE TOLLIVER
Untitled (Moose Lady), ca. 1970s, paint on board and human hair, 24 x 14 1/2 inches, collection of Claudia DeMonte and Ed McGowin.

of outsider art? MacGregor presents a theory:

> *Dubuffet's sociological, even political, conception of the Outsider as a social outcast, madman, prisoner, or isolate—a poor and culturally illiterate individual existing on the margin of his society—is repellent to Americans, with democratic notions of equality forcing them to ignore or deny the reality of the socially marginal individual and his art* (MacGregor 1991, 10).

In a closing statement, MacGregor sums up his compatriots' reluctance to limit outsider art to work by the mentally isolated:

> *The Outsider, the insane man or woman, the prisoner, the social outcast, the illiterate, the poor, and the isolated, all point to fundamental problems in our society, to a psychopathology inherent in the social fabric* (MacGregor 1991, 30).

This image of outsider art as the product of a dysfunctional person in a dysfunctional society is very much at odds with Cahill's definition of folk art as embodying the essence of a morally upright, self-sufficient, democratic society: it is no wonder that Americans are slow to welcome the term as first defined by Dubuffet.

Despite the wide variance in points of view, perhaps inevitable given the broad range of material which can be approached from many different angles, the evolution of appreciation of the work of untrained artists has followed a fairly consistent course. It began with Cahill's generation, which by the 1930s was willing to call "folk art" anything by an unschooled artist or artisan—painting, drawing, sculpture, or artifact, functional or not, as long as it was made before the twentieth century, and preferably before the Civil War. Key to this understanding, however, was that the artist was integrated into his community and operating to a large degree out of community traditions and values. In the 1930s, as interest in the work of twentieth-century painters grew, increasing emphasis was placed on the presence of the individual in the work, and less was put on community values and traditions. Thus painting was considered separate from sculpture, which was often perceived as utilitarian, and therefore folk art. In the 1970s, beginning with Cardinal's concept of outsider art, the individual began to be seen as the driving force behind much of the work of twentieth-century untrained artists. In the case of artists that were considered true outsiders by Dubuffet's most restrictive definition, community values, even if present, became in a sense irrelevant, as MacGregor astutely points out. Theoretically, work that is outsider art cannot be folk art, but the concept of outsider art heightened appreciation for the more unusual kinds of work that conformed to the older concept of folk art. This synopsis, however, is quite simplistic, since almost every position, trend, or definition that evolved during the twentieth century continues to be represented to some degree by someone, somewhere.

AN ART OF PASSION

One issue on which almost everyone can agree with regard to the twentieth-century untrained artists who have become so popular since 1980 is their evident lack of any design to be considered artists. Unlike Henri Rousseau, Morris Hirshfield, or Drossos Skyllas, they do not aspire to be "colleagues of professionals." They refuse to carry on a dialogue with high art. They make their art for themselves, not for the art world—they do not create their work through the eye of the schooled artist. They may look at fine art, but they do not view it as a historical continuum in which they want to position themselves. When they borrow bits and pieces from this visual history, they do so not to make a reference to its significance or content, but because the borrowings have personal significance to them. They just as readily borrow images and objects from popular culture, television, architecture, advertising, magazines—any manmade artifact that holds meaning for them is available for appropriation. Generally, they are not interested in selling their art, although they

FIG. 23. THORNTON DIAL
The Reservoir, 1990, oil on canvas, 71 x 96
inches, collection of David T. Owsley.

are often given the opportunity to do so. Some give their work away. Others fill their yards and cover their homes, inside and out, with it. Many never show it to anyone, including immediate family. Most are compulsive about making their art, and use much of their time to produce it.

As has been noted, the highly personal nature of the work—the intense psychological, emotional, and even physical involvement of the individual in its creation—has proved to be one of its most striking qualities for many viewers. Nevertheless, a question seldom asked is, How does this relationship to the work, which is so different from that of the trained artist, manifest itself in terms of the meaning of the work?

A painting by Thornton Dial, *The Reservoir* (**FIG. 23**), included in this exhibition, helps clarify this question.

Seen in a New York contemporary art gallery without a label or identification of any kind, this large-scale work might well appear to the most experienced gallery-goer not familiar with self-taught art to be the work of a fine artist. Elements reminiscent of Francesco Clemente, Julian Schnabel, and the German neo-expressionists haunt the work. The extraordinary balance between mark-making and representation is characteristic of this period, and the nicely squared and stretched canvas, in large post-1945 scale, announces the work of a schooled artist. But this is not ordinary contemporary art—it is contemporary self-taught art.

Once we know this, the same marks, forms, colors, and images take on a different meaning. The painting itself has not changed, but its *meaning* has, because the relationship of the artist to the artwork is critical for understanding the meaning of the work, and the relationship of the untrained artist to his or her work is very different from that of the schooled artist.

The finest discussion of this relationship can be found in Donald Kuspit's essay "'Suffer the Little Children to Come unto Me': Twentieth Century Folk Art," which appeared in the Milwaukee Art Museum catalogue of a 1981 exhibition, *American Folk Art: The Herbert Waide Hemphill, Jr., Collection*. In it, he draws an analogy between folk art and toys, deriving some of his basic premises from Charles Baudelaire's modernist treatise *A Philosophy of Toys*. According to Kuspit, the toy represents a make-believe world that the child transforms into reality; interaction with it becomes a way to cope with the real world, to structure it and place oneself within it. The toy can be a simple, stripped-down object, embodying the essence of what is at issue, rather than the irrelevant, unnecessary, or meaningless details of the visual world. And because children have no preconceived notions, everything in their world is new, fresh, and possible, and thus readily accepted.

Similarly, folk art becomes a place for folk artists to invest their feelings about the world as they know it and as they emotionally respond to it. Like the toy, folk art is abstracted to present the essence of reality, and this abstraction is the result of the intensity of the feelings and passions of the artist responding to reality. Kuspit describes the creative process as follows:

> *The folk toy is a construction that is a sign of impulsive, involuntary curiosity, childishly grabbing what it can from the worldly objects with which it has indeterminately littered its life....The toy, by reason of its "drunken," apparently "ecstatic" ordering of raw material, embodies childhood's powerful perspective, making all raw material miraculously "new," articulate in a way all but children find unexpected* (Kuspit 1981, 38–39).

Folk art, because of the relationship of the artist to his immediate environment, has a "psychosocial function in the contemporary art world"; its importance lies in the reuniting of thought and feeling in art, eliminat-

ing the "dissociation of sensibility…that T. S. Eliot described as the modern spiritual disease":

> *[Folk art] combines self-consciousness about artistic making and a retreat into the fathomless feeling of the child—into a realm in which feeling and thought have not yet become separate and neither has attempted to usurp the role of the other* (Kuspit 1981, 40).

This is an art based on passion and personal need, and not on aesthetic criteria established by others.

Kuspit's basic assertion of the presence of the soul or essence of the artist in the folk object rings true, especially since others have made the same observation—Cahill and Gauthier in 1938, Cardinal very emphatically in 1972, Flood hesitantly in 1981, and Livingston in 1982, to name a few. Clearly, folk art can contain an emotional and psychic intensity not found in schooled art, and this intensity is not in the work as intellectually calculated signs and symbols: it is just there. It is in the mark making, in the selection of motifs, and in the selection of materials—all of which come from the soul, from an "'ecstatic' ordering of raw material," "a childish grabbing." The resulting object, designed only to meet the needs and passions of its maker, conforms to no preconceived notions of art. Artistically, nothing is new for the folk artist. The artwork itself is, in a sense, less an end product than a means. This may in part account for the apparently obsessive compulsion many folk artists have to make their work, and their lack of interest in exhibiting it.

Looking at Dial's *The Reservoir* with the knowledge that it is the work of a self-taught artist, we can easily sense the intensity of the creative process, and of the presence of the self in the picture. The powerful brushstrokes, the way the faces loom out from the density of the paint and press up to the very surface of the image, the sharpness of the chopped-off cross-section of conduits—all was achieved unselfconsciously. Dial was not concerned with making anyone marvel at these qualities, or at the cleverness with which he devised his composition and selected his themes, motifs, and subject matter. That the work should look like the painting of schooled artists of the last ten years is in some respects coincidental.

Dial himself explains why he makes art:

> *Art ain't about paint. It ain't about canvas. It's about ideas. Too many people died without ever getting their mind out to the world. I have found how to get my ideas out and I won't stop. I got ten thousand left* (Maresca and Ricco 1993, 35).

Dial's ideas are concerned with social conditions in America, particularly in the South, and especially as they affect African-Americans. His work presents these ideas in the form of a state of mind, a spirituality, a physicality. It captures many local and regional perspectives on the issues that concern him. Of *The Reservoir*, Dial has said, "Water is where life begins. The power of the man be in the water. The pipes carry the water" (Whelchel and Donovan 1993, 92). This statement is sufficient to describe the work. It is the essence of the painting, and conveys the degree of self Dial has magically woven into his art. We sense his powerful identification with the faces, and his pride in identifying with the tiger—the largest head in the composition. We sense his belief in the phallic symbolism of the pipes, through which the seminal water that perpetuates his people runs. We can also sense the degree to which Dial is speaking for a large number of people—of the "folk"—who share his concerns and who have helped shape the vocabulary, including the metaphors and myths, that he has used.

Dial's painting is especially relevant to any discussion of the difference between folk art and academic contemporary art, because his work can easily be confused with that of a fine artist, just as the work of many fine artists may look self-taught. In fact, Dial has one foot in the art world, so to speak, having had a two-museum exhibition in Manhattan in 1993, at the New Museum for Contemporary Art and the Museum of American

Folk Art. He attended the openings and participated in the educational programming, and was taken to other museums in New York, where he looked at the art. There are those who complain that this contact with the art world seriously compromises his sincerity and his naïveté—his authenticity. His large, professionally stretched canvases, supplied by his dealer, are evidence of his lack of innocence. The mere fact that he has a dealer, the art is sold, and he lives well because of the sale of the work is supposed to be further proof that he is not genuine. Yet when he goes back home to Bessemer, Alabama, he makes art from his soul, for himself, out of the inner need to get his ideas out. He is compelled to make it whether or not there is a dealer, whether or not there are people to buy the work, and whether or not the work is seen.

Into which category of untrained artist does Dial fall? Folk, self-taught, or outsider? Do the tremendous passion and the obvious presence of the individual in the painting qualify him as a self-taught artist? Even though he may have developed a personal iconography for his work, can we move him into the category of folk, since his values come out of the linked communities of African-Americans and Southern labor and the concerns he expresses are common property? Clearly, he does not qualify as an outsider—at least not by MacGregor's rigorous definition—since the social influences present in the work cannot be ignored or dismissed. Yet, despite the presence of strong cultural signs that carry meaning for the work, the magic of his paintings lies in their powerful subjectivity.

Is there, finally, any point to labeling Dial's work? Certainly learning about the circumstances that account for its existence would be a more meaningful exercise, as the folklorists and Daniel Robbins have contended. Nonetheless, there is a need to distinguish it from the "other art"—fine art. It is the painting of the artist's self into his art that makes this work so magical: this quality is, in part, the meaning of the work—and is exactly what work by schooled artists does not have. This is why, although nearly everyone today wants the work to be called simply "art," the search for a specific label continues.

It is difficult to label Dial a folk artist, since he works in aesthetic isolation and not out of a tradition. Archetypal folk artists—the nineteenth-century makers of trade signs, fish lures, whirligigs, face jugs, quilts, figure-heads, cigar-store figures, and hooked rugs—were by and large doing what everyone else who made these objects did, and in many instances, their products ended up in the public domain. They were often paid for their work, as was the nineteenth-century limner, who was merely providing a product that the community wanted. Silhouette portraits, tinsel still lifes, and paintings on glass and velvet also fall into the category of work made to fit certain expectations, perhaps basically for personal enjoyment, but probably on occasion for profit as well. Most people were taught, even if informally, the crafts of whittling, carving, sewing, painting, drawing, and shaping and firing clay. In the twentieth century, the medium may have changed, but the issue of tradition remains, as can be seen in the work of people who make art out of bottle caps, popsicle sticks, and found objects in general.

Does Dial's work fall into this category? The answer is probably no. In the late 1970s and early 1980s, he began working in assemblage, often with patio furniture, and then started painting on plywood. There is no evidence that he had any sense of working in a tradition. He seems instead to have been operating in a vacuum of sorts—in aesthetic isolation. He was not making pictures of his house, of famous landmarks, or of loved ones to decorate his walls, as traditional nineteenth-century folk artists did. Instead, he felt driven to speak out about his situation as an African-American in the South, unleashing his anger at social injustice while simultaneously demonstrating great pride in being a black man. His art became the vehicle for the expression of these feelings. Although he may not have had an audience in mind, his need to communicate is powerful. It is perhaps ironic that while his art reflects the concerns of many people in his community, his is not a public art that can easily be reabsorbed back into the community.

Dial's intense passion—the identification of the self in the painting—and the absence of any concern to place himself within an aesthetic tradition are what distinguish his work from much traditional folk art—and from fine art as well. Since folk artists operate from well-defined traditions, they do not draw upon the self to anything like the extent shown by Dial and the other artists in *A World of Their Own*. Because they do not work out of a driving passion, and because they consciously position themselves in relation to other makers in the traditions in which they work, folk artists are closer to fine artists than to self-taught artists. Ultimately, it is difficult to slip Dial's work comfortably into the category of either folk or fine art.

Based on these observations about the significance of the self and aesthetic traditions in the work, it is possible to identify useful labels. If we define folk art as utilitarian and coming out of distinct folk traditions, we separate one body of work by untrained artists from another. The pure painting, drawing, sculpture, and environments fill a second category, which is most often, and perhaps most usefully, labeled "self-taught." From this material, a third category can be derived: outsider art. This is art made by people who work in a trancelike or altered state of mind—people who are isolated by mental illness or other mental handicaps, in which social and cultural references are of little interest, except as vehicles to carry the artist's psychological intensity.

These three categories have been used with greater regularity in recent years, although they are far from finding universal acceptance. They must, however, be used with caution, and in no hierarchy of importance. The need to separate painting and sculpture from utilitarian objects should not reflect a judgment of quality or significance. Nor should the categories be rigid. We cannot measure art. We cannot measure it for the degree of self it contains, for the extent to which it comes out of aesthetic traditions, or for the significance of its cultural signs. David Butler, for example, was clearly influenced by whirligig and weathervane traditions, but he dramatically transformed those traditions into a unique environment far removed from its folk sources. At what point does he cross the line between folk and self-taught? Henry Darger held a job as a custodian and was never institutionalized, but he was otherwise a recluse, living in a fantasy world in a tiny rented room that was crammed with piles of newspapers and magazines, balls of string, and hundreds of smashed eyeglasses and pairs of shoes. At what point does he cross the line between self-taught and outsider? Howard Finster has been in numerous exhibitions, has visited museums and galleries, and has even been on the Johnny Carson Show. At what point has his awareness of other art and an art market compromised his innocence and his genuineness as a self-taught artist, propelling him into the world of fine art? At what point is the passion no longer spontaneous or deeply felt, and thus significant? When confronted with this difficulty of measurement, the temptation to resolve it simply by designating all work by untrained artists as folk art is readily understandable.

In the end, we must look at the artists one at a time, and learn to analyze the rich cultural, social, and historical forces that mold the art and its makers and the intense passions that drive their work. When we do, we will discover that the categories tell us little—that each artist is a distinct individual, and each creates distinct work. The best work by untrained artists is made in aesthetic isolation: it is unique, and does not readily relate to any other art. By its very nature, it defies categorization. Labeling it does it an injustice, and assigning a quantitative value to the artist's passion—the degree to which the artist is totally immersed in and committed to the fictitious world he or she is creating—demeans it. What makes the art so meaningful is its passionate individualism, and this individualism must be honored first and foremost.

REFERENCES

Ames, Kenneth L. 1980. "Folk Art: The Challenge and the Promise." Pp. 293–324 in *Perspectives on American Folk Art*, edited by Iam M. G. Quimby and Scott T. Swank. New York: W. W. Norton & Co.

————. 1994. "Outside Outsider Art." Pp. 252–72 in *The Artist Outsider: Creativity and the Boundaries of Culture*, edited by Michael D. Hall and Eugene W. Metcalf, Jr. Washington, D.C.: Smithsonian Institution Press.

Barr, Alfred H., Jr. 1938. "Preface and Acknowledgements." Pp. 9–10 in *Masters of Popular Painting: Modern Primitives of Europe and America*. Exhibition catalogue. New York: The Museum of Modern Art.

Barrett, Didi. 1986. "Muffled Voices: Folk Artists in Contemporary America." Pp. 4–11 in *Muffled Voices: Folk Artists in Contemporary America*. Exhibition catalogue. New York: Museum of American Folk Art.

Black, Mary, and Jean Lipman. 1966. *American Folk Painting*. New York: Clarkson N. Potter.

Blasdel, Greg N. 1968. "Grass-Roots Artist." *Art in America* 56(September–October):24–41.

Cahill, Holger. 1930. "Introduction." Pp. 7–9 in *American Primitives: An Exhibit of the Painting of Nineteenth Century Folk Artists*. Exhibition catalogue. Newark, N.J.: The Newark Museum.

————. 1931. "American Folk Sculpture." Pp. 13–18 in *American Folk Sculpture: The Work of Eighteenth and Nineteenth Century Craftsmen*. Exhibition catalogue. Newark, N.J.: The Newark Museum.

————. 1932. "American Folk Art." Pp. 3–28 in *American Folk Art: The Art of the Common Man in America, 1750–1900*. Exhibition catalogue. New York: Museum of Modern Art.

————. 1938. "Artists of the People." Pp. 95–105 in *Masters of Popular Painting: Modern Primitives of Europe and America*. Exhibition catalogue. New York: Museum of Modern Art.

————. 1950. "Introduction." Pp. ix–xvii in *The Index of American Design*, edited by Erwin O. Christiensen. New York: MacMillan.

Cardinal, Roger. 1972. *Outsider Art*. London: Studio Vista.

————. 1994a. "Toward an Outsider Aesthetic." Pp. 20–43 in *The Artist Outsider: Creativity and the Boundaries of Culture*, edited by Michael D. Hall and Eugene W. Metcalf, Jr. Washington, D.C.: Smithsonian Institution Press.

————. 1994b. "The Self in Self-Taught Art." *Art Papers* 18(September–October):28–33.

Carraher, Ronald G. 1970. *Artists in Spite of Art*. New York: Van Nostrand Reinhold.

Coffey, Katherine. 1959. "History of the Newark Museum Association." Pp. 7–25 in *The Newark Museum: A Survey*. Newark, N.J.: The Newark Museum.

Dana, John Cotton. 1917. *The Gloom of the Museum*. New Museum Series, no. 2. Woodstock, Vt.: Elm Tree Press.

Egner, Arthur F. 1931. "Foreword." Pp. 9–10 in *American Folk Sculpture: The Work of Eighteenth and Nineteenth Century Craftsmen*. Exhibition catalogue. Newark, N.J.: The Newark Museum.

Flood, Richard. 1981. "Ecstasy and the Doodle." Pp. 5–7 in *Transmitters: The Isolate Artist in America*. Exhibition catalogue. Philadelphia: Philadelphia College of Art.

Friedman, Martin. 1974. "Introduction." Pp. 7–11 in *Naives and Visionaries*. Exhibition catalogue. New York: E. P. Dutton & Co.

Gauthier, Maximilian. 1938. "Maîtres Populaires de la Réalité." Pp. 17–24 in *Masters of Popular Painting: Modern Primitives of Europe and America*. Exhibition catalogue. New York: Museum of Modern Art.

Goldwater, Robert. 1966. *Primitivism in Modern Art*, rev. ed. New York: Vintage Books.

Hall, Michael D., and Julie Hall. 1981. "Transmitters: A Dialogue on the Isolate Artist in America." Pp. 8–52 in *Transmitters: The Isolate Artist in America*. Exhibition catalogue. Philadelphia: Philadelphia College of Art.

Hall, Michael D., and Eugene W. Metcalf, Jr., eds. 1994. *The Artist Outsider: Creativity and the Boundaries of Culture*. Washington: Smithsonian Institution Press.

Hartigan, Lynda Roscoe. 1990. "Collecting the Lone and Forgotten." Pp. 1–80 in *Made with Passion*. Exhibition catalogue. Washington, D.C.: Smithsonian Institution Press.

Hemphill, Herbert W., Jr. 1976. "Introduction." Pp. 7–8 in *Folk Sculpture USA*, edited by Herbert W. Hemphill, Jr. Exhibition catalogue. Brooklyn, N.Y., and Los Angeles: The Brooklyn Museum and Los Angeles County Museum of Art.

Hemphill, Herbert W., Jr., and Julia Weissman. 1974. *Twentieth-Century American Folk Art and Artists*. New York: E.P. Dutton & Co.

Janis, Sidney. 1942. *They Taught Themselves*. New York: Dial Press.

Jeffers, Wendy. 1991. "Holger Cahill and American Art." *Archives of American Art Journal* 31(4):4–11.

————. 1994. Telephone conversations with the author, September 1994.

Jones, Michael Owen. 1980. "L.A. Add-ons and Re-dos: Renovation in Folk Art and Architectural Design." Pp. 325–64 in *Perspectives on American Folk Art*, edited by Iam M.G. Quimby and Scott T. Swank. New York: W.W. Norton & Co.

Kuspit, Donald. 1981. "'Suffer the Little Children to Come unto Me': Twentieth Century Folk Art." Pp. 37–47 in *American Folk Art: The Herbert Waide Hemphill, Jr., Collection*. Exhibition catalogue. Milwaukee: Milwaukee Art Museum.

Lipton, Barbara. 1979. "John Cotton Dana and the Newark Museum." *The Newark Museum Quarterly* 30(2 and 3, Spring/Summer):1–57.

Livingston, Jane. 1982. "What it is." Pp. 11–23 in *Black Folk Art in America, 1930–1980*. Exhibition catalogue. Jackson, Miss.: University Press of Mississippi, Jackson, and the Center for the Study of Southern Culture.

MacGregor, John M. 1991. "Altered States—Altered Worlds." Pp. 10–33 in *Outsider USA*. Exhibition catalogue. [Sweden]: Thord Thordeman.

Manley, Roger. 1989. "Seed and Shadow." Pp. 3–53 in *Signs and Wonders: Outsider Art Inside North Carolina*. Exhibition catalogue. Raleigh: North Carolina Museum of Art.

Maresca, Frank, and Roger Ricco. 1993. *American Self-Taught: Paintings and Drawings by Outsider Artists*. New York: Alfred A. Knopf.

Metcalf, Eugene W., Jr. 1986. "The Politics of the Past in American Folk Art History." Pp. 27–50 in *Folk Art and Art Worlds*, edited by John Michael Vlach and Simon J. Bronner. Ann Arbor, Mich.: UMI Research Press.

Metcalf, Eugene W., Jr., and Claudine Weatherford. 1988. "Modernism, Edith Halpert, Holger Cahill, and the Fine Art Meaning of American Folk Art." Pp. 141–66 in *Folkroots, New Roots: Folklore in American Life*, edited by Jane S. Becker and Barbara Franco. Exhibition catalogue. Lexington, Mass.: Museum of Our National Heritage.

Robbins, Daniel. 1976. "Folk Sculpture with Folk." Pp. 11–31 in *Folk Sculpture USA*, edited by Herbert W. Hemphill, Jr. Exhibition catalogue. Brooklyn, N.Y., and Los Angeles: The Brooklyn Museum and Los Angeles County Museum of Art.

Rumford, Beatrix T. 1980. "Uncommon Art of the Common People: A Review of Trends in the Collecting and Exhibiting of American Folk Art." Pp. 13–53 in *Perspectives on American Folk Art*, edited by Iam M.G. Quimby and Scott T. Swank. New York: W.W. Norton & Co.

Steel, David. 1989. "Introduction and Acknowledgments." Pp. ix–xii in *Signs and Wonders: Outsider Art Inside North Carolina*. Exhibition catalogue. Raleigh: North Carolina Museum of Art.

Stillinger, Elizabeth. 1994. "Elie and Viola Nadelman's Unprecedented Museum of Folk Arts." *Antiques* 146(4):516–25.

Thordeman, Thord. 1991. "Introduction." Pp. 8–9 in *Outsider USA*. Exhibition catalogue. [Sweden]: Thord Thordeman.

Tucker, Marcia. 1981. "Preface." Pp. 4–5 in *Transmitters: The Isolate Artist in America*. Exhibition catalogue. Philadelphia: Philadelphia College of Art.

Vlach, John Michael. 1985. "Holger Cahill as Folklorist." *Journal of American Folklore* 98(388):148–62.

————. 1986. "'Properly Speaking': The Need for Plain Talk about Folk Art." Pp. 13–26 in *Folk Art and Art Worlds*, edited by John Michael Vlach and Simon J. Bronner. Ann Arbor, Mich.: UMI Research Press.

Weiner, Elsa S. 1981. "Foreword." P. 3 in *Transmitters: The Isolate Artist in America*. Exhibition catalogue. Philadelphia: Philadelphia College of Art.

Whelchel, Harriet, and Margaret Donovan. 1993. *Thornton Dial: Image of the Tiger*. New York: Harry N. Abrams.

Winser, Beatrice. 1930. "Foreword." P. 5 in *American Primitives: An Exhibit of the Painting of Nineteenth Century Folk Artists*. Exhibition catalogue. Newark, N.J.: The Newark Museum.

BIOGRAPHIES

ARTIST UNKNOWN
("PHILADELPHIA WIREMAN")

ACTIVE CA. 1960s–70s

UNTITLED

ca. 1960s–70s

mixed-media assemblage, 17 1/2 x 5 1/8 x 4 3/4 inches

The Newark Museum, Purchase, 1992, Eleanor S. Upton Bequest Fund, 92.21

The entire oeuvre of the "Philadelphia Wireman" was found one night in 1983 or 1984 on South Street in central Philadelphia. Over seven hundred assemblages in cardboard boxes had been put out at the curb for trash collection, where they were discovered and retrieved by a local graphic designer. Several years later, the designer took them to John Ollman, the director of the Janet Fleisher Gallery, where they were first shown in 1987.

The sculptures range in height from a few inches to several feet high, although the vast majority are under eight inches. All consist of mundane objects bound in wire, and most conform to an elongated, anthropomorphic form. The embedded objects can be any everyday material, ranging from cigar wrappers and ticket stubs to electrical components and paper clips. Based on the age of these objects, the work has been dated between 1960 and 1976, although this method is suspect, since it presumes that the works were made when the objects were. The artist is often described as African-American because the work was found in a black neighborhood and because it has a ritualistic or fetishistic quality—the latter a problematic correlation. The works are often considered spiritual charms or power objects, and have been compared to African *nkisi*, talismans that provide protection. Harry's Occult Shop, the only shop of its kind in south Philadelphia, was located just one block from where the sculptures were found.

Although claims about the ethnic and shamanistic qualities of the work cannot be substantiated, the sculptures are nonetheless mysterious and exotic. The objects embedded in them seem to contain provocative histories, which lend poetry to the work. The wrapping of wire, rubber bands, and plastic adds a nervous tension.

There is no way of knowing for sure that these formalistically brilliant pieces are not the work of a schooled artist, although it is highly unlikely that such a person would remain unidentified. The meaning of these works would be quite different if made by a trained artist as opposed to a self-taught artist.

ARTIST UNKNOWN
("MASTER OF THE WOODBRIDGE FIGURES")

ACTIVE CA. 1940s–50s

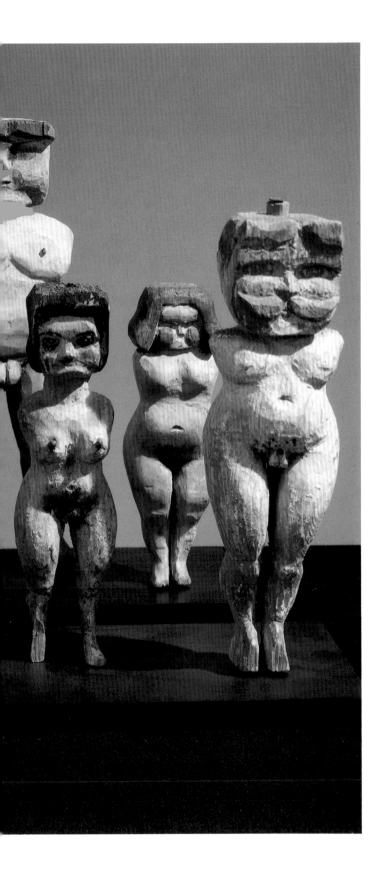

UNTITLED

ca. 1940s–50s

polychromed wood, 13 figures, ranging in height from 4 1/2 to 7 3/4 inches

Collection of Gael Mendelsohn

In the mid-1980s, a New Jersey dealer in antique dolls brought just over one hundred wood figures to the New York folk art dealer Roger Ricco. The objects, most ranging in height from four to seven inches, represented men, women, and children, all somewhat different and individualized and all without arms. A handful of the children had tags attached that identified the figure as the son or daughter of a particular person, first names only being used. Inserted in the heads of most of the figures were plugs. Herbert Hemphill, upon learning of the cache of strange figures, went to see them, and happened to pull a plug out. It was a penis. Hemphill proposed that the figures were used for fertility rituals, and were objects of empowerment.

The New Jersey dealer told Ricco that the figures came from a shack in the woods where the Woodbridge, New Jersey, Shopping Center now stands. Although the mall had been built some twenty years before, in the 1960s, some people in the area remembered that there had been strange activity in the woods. Many felt the shack had been used as a chapel, and that services of some sort took place there. Beyond this, nothing else is known.

The lack of arms, the peg penises, the harsh frontality, the intense stares, the strange black stockings, the blood-red cheeks and nipples, and the deep angular cuts juxtaposed with rounded swelling forms all give these figures a forceful presence and a fetishistic quality. Like the sculptures of the "Philadelphia Wireman," these objects may have had a utilitarian component, but aesthetically they are powerful, seeming to reflect a strong artistic vision and a passionate involvement in their function.

WILLIAM A. BLAYNEY

1917–1986

MURAL OF COMBINED PROPHECIES OF FIGURES AND SYMBOLS OF THE BOOKS OF DANIEL AND REVELATION OF THE HOLY BIBLE

1956

oil on Masonite

48 1/4 x 34 3/8 inches

Collection of David T. Owsley

Blayney was born in rural Pennsylvania near the West Virginia border, and his family moved to Pittsburgh when he was twelve. He never entered high school, and instead went to welding and auto school. After a stint in the army during World War II, he operated a bulldozer and other heavy equipment before opening an automobile repair shop. His lifestyle included motorcycle riding and heavy drinking. Sometime in the mid-1950s, he found religion: he became an ardent follower of Kathryn Kuhlman's Pentecostal Church and spent much of his time reading the Bible. He began painting about 1956.

All of Blayney's known works are religious, although references exist to portraits of his first wife, Alice, and of Kuhlman. In 1966, he abandoned his wife without warning and went to Arizona, California, Nevada, and Texas before settling in Thomas, Oklahoma. At some point during this odyssey, Blayney became an ordained minister of the Pentecostal Church and remarried. He and his wife were recluses, living in several trailers and a school bus on a piece of property that was surrounded by a white picket fence surmounted with crosses and do-not-trespass signs. Periodically, they would disappear for long stretches, supposedly for Blayney to preach. Blayney was discovered by David T. Owsley, Curator of Antiquities, Oriental and Decorative Arts at the Carnegie Institute, who came upon some of his work at a local flea market—paintings owned by the artist's first wife and consigned to an antique dealer upon her death. In 1980, Owsley showed Blayney's paintings at the museum. The artist, who was presumed dead, wrote to Owsley, informing him that he had shown one of his sand paintings at the museum in 1956, although there is no record of this.

Blayney is often described as a visionary because of the hallucinatory nature of his work, which is populated by frightening multiheaded animals and faceless Babylonian kings. His imagery is not entirely imagined, however, since it most likely comes directly from the illustrations in the Bibles that he spent so much time reading. Unfortunately, these Bibles were destroyed in a fire after his death. But Blayney's motifs and diagrams are identical to those found in millennial illustrations of passages from the books of Daniel and Revelation, which Blayney was familiar with through the Pentecostal Church.

Blayney most likely used his large panels, such as *Mural of Combined Prophecies*, when he preached—he implied as much in his correspondence with Owsley, and the works are punctured by nail holes. They are powerful admonitions against sin, which is represented by the beasts and the Babylonian king. The grotesqueness of the images, Blayney's expressionist paint handling, and the obsessive writing, often in graphite, give these works a frightening apocalyptic quality.

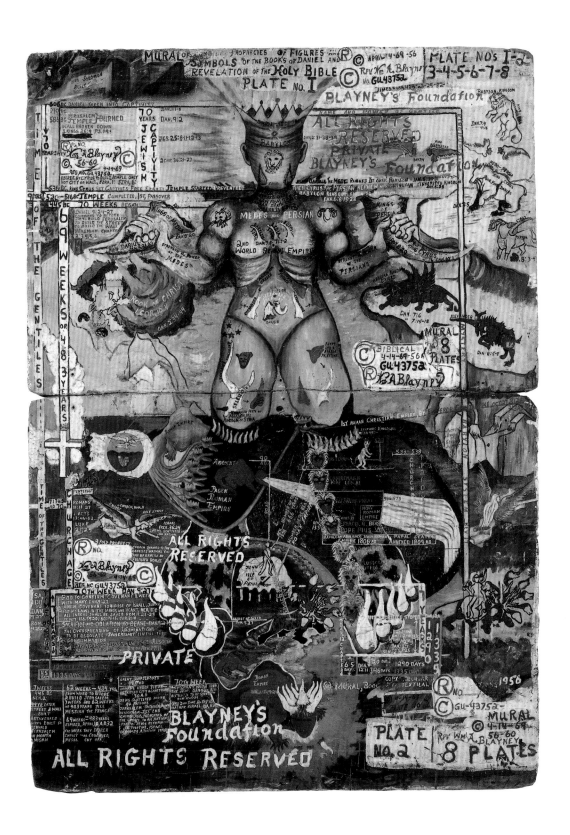

DAVID BUTLER

BORN 1898

THE NATIVITY

ca. 1970s

cut and painted tin with wire

27 3/4 x 36 1/2 x 2 1/2 inches

The Newark Museum, Bequest of Edmund L. Fuller, Jr., 1985, 85.422

David Butler was born into a large African-American family in rural Louisiana. He never left the area where he was born and raised, and he worked most of his life at menial jobs, the last in a sawmill. A job-related injury forced him to retire in the mid-1960s. A few years later, he produced his first painted tin constructions when poverty forced him to make his own shutters or screens to protect his house from storms and intense light. He used found tin, painted images on it with house paint, and perforated it to allow for air and some light, magically integrating the perforations into the images. Encouraged by the artistic success of these works, he made painted metal cutouts for his house and yard, covering large portions of both. His images include the real and the imaginary: animals and people, trains, winged donkeys, sea monsters and mermaids. Often he accented his paintings with buttons, metal washers, and plastic accessories for dolls and toys. The cutouts in the yard were affixed to stakes and boards, and many were designed as whirligigs. Butler entered a nursing home in 1984 and has stopped working.

Despite claims to the contrary, Butler is not particularly religious, and he did not make his work because he was inspired by God. He has said that he made art because it was a way to occupy his time after his wife died, in about 1968. He has also said that his ideas often came to him from dreams or when lying in bed. His rare religious themes are limited to Nativity scenes, which he made for the Christmas holidays.

Butler clearly comes out of the folk tradition of whirligigs and weathervanes. The world he created extends well beyond this tradition, as he transformed his yard and home into a unique environment densely populated by playful, demonic, and fanciful people and creatures. Butler's art is distinguished by its bright primary and secondary colors and a style that is quite abstract, employing highly decorative patterns.

One of the princesses Violet by name (arrow shows her) was captured by general Federals Glandelinians, who buried her up to her neck in sand and left her to perish of thirst, but her sisters rescued her.

HENRY DARGER

1892–1973

previous page:

THEY ARE SHOOTING AT ENEMY SOLDIERS/ AT MT. HALLESTON

n.d.

watercolor, pencil, and carbon ink on paper

18 x 48 inches

Collection of Sam and Betsy Farber

Photograph courtesy of Phyllis Kind Gallery, New York

Henry Darger's mother died when he was about four, and his father, a physically disabled tailor, placed him in a Catholic home for boys when he was eight. After being deemed too unruly and sent to an asylum, he ran away at the age of sixteen. Beginning in 1915, he held janitorial positions in a number of Chicago hospitals, retiring at the age of seventy-one. He had no social life and only one friend, although he was a devout Catholic and attended church regularly. He lived in rented rooms. Six months before he died, he asked his last landlord, the photographer Nathan Lerner, to take him to a Catholic nursing home.

Lerner was astonished by what he found in Darger's tiny apartment: hundreds of balls of string and pairs of shoes, dozens of smashed eyeglasses, piles of newspapers, magazines, and telephone books, an extensive autobiography, and a 15,145-page typewritten fantasy epic entitled "The Story of the Vivian Girls in What is Known as The Realms of the Unreal, of the Glandeco-Angelinnean War Storm, Caused by the Child Slave Rebellion." Begun in 1911 and heavily influenced by Darger's knowledge of the American Civil War, the book tells the story of terrible battles fought over child slavery, with the ruthless Glandelinians enslaving children, especially girls. Defending the children are the Abbieannians and denizens of other Christian nations, who are lead by the seven Vivian girls—who are model Catholics, courageous leaders, and brilliant military strategists. Periodically, Blengiglomenean serpents appear to help the children.

Darger illustrated this fantasy with well over three hundred drawings. It is not known when he began making the art, although it seems to have existed by the 1940s. Darger would cut out pictures of little girls from magazines and newspapers, photograph them, enlarge them, and trace them into his drawings, which would often contain a mixture of collage, watercolor, and pencil, in addition to carbon tracing. The images range from pleasant or idyllic depictions of the girls at home or in a country setting to horrific scenes in which children are being viciously mutilated by Glandelinians. There appears to be a direct correlation between the tenor of the scene and the artist's state of mind as he weaves his moral fantasy of sadism, evil, heroism, and virtue. While the drawings have been described as illustrational, they are remarkable for their deft handling of formal qualities. Darger's play of texture, shifts in scale, value contrasts, spatial distortions, and rich busy surfaces, filled with both formalist and representational detail, all make his drawings a feast for the eyes.

THORNTON DIAL, SR.

BORN 1928

KNOWING THE ROAD

1993

mixed media on board

56 x 78 x 6 inches

Courtesy of Phyllis Kind Gallery, New York

Thorton Dial was born in Emmel, Alabama. He was sent to live with an aunt at age ten, and when she died, he went to live with his grandmother in Bessemer, where he lives today. He dropped out of school in the fourth grade and began working at a number of odd jobs, which he continued to do for most of his life. From 1952 to 1980, he worked periodically at the Pullman Standard Company, which manufactured railroad cars in Bessemer. When laid off, he repaired underground pipes for the Bessemer Water Works. From 1984 to 1987, he operated a wrought-iron patio and lawn furniture shop in his home.

There is some question about when Dial began making his art, although he appears to have been making metal assemblages by the late 1970s and early 1980s. Gradually he began to paint on plywood. He was discovered in 1987 by an Atlanta art dealer, William Arnett, who several years later arranged to provide him with professionally stretched canvases. In the 1990s, Dial began building up the surfaces of his paintings with found objects.

Dial's art is driven by his need to communicate his feelings about contemporary society, especially his experience as an African-American in twentieth-century America. He often makes his point metaphorically. For example, the tiger is the African male, and the jungle he travels through refers to the trials and tribulations presented by American society. Often the found materials embedded in Dial's canvases relate directly to the experiences he is describing. His style is bold and dramatic. His faces, figures, or animals are generally frontal or in profile, pressed up to the surface of the image and often filling the entire field. They are generally constructed out of a minimal number of explosive brushstrokes that further charge his images.

SAM DOYLE

1906–1985

ADLADE

n.d.

house paint on tin

54 x 38 inches

Collection of Dr. and Mrs. Richard U. Levine

Photograph courtesy of Edward Thorp Gallery, New York

Sam Doyle was born into a farm family on the remote island of St. Helena, off the South Carolina coast. The island was populated by former slaves or descendants of slaves and was so isolated that many people continued to practice African traditions and to speak Gullah, a variant of a West African language. Doyle attended a Quaker school until the ninth grade, leaving to take a job as a clerk in a local store. From 1930 to 1950, he worked off the island as a porter for the McDowne Company, a wholesale store in Beaufort, after which he was employed in the laundry at the Marine Corps base on Parris Island. He retired in 1967, although he took a part-time job as a caretaker for the Chapel of Ease, a landmark in Frogmore, where Doyle lived on the family property, which he no longer farmed.

In 1932 or shortly thereafter, Doyle married a New York City woman, who, tired of remote island life, returned to the city about 1944, taking their three children with her. Apparently Doyle began to paint after his wife left him. He had received art training in school, and appears to have been very good. Despite this background, he chose to use house paint on found materials, principally corrugated roof tin, but also plywood and window shades. The themes of his painting were island life, both the people and African traditions. *Adlade*, for example, documents both the African tradition of carrying heavy objects on the head and the use of a second belt. The belt not only hoists skirts up to keep them clean but endows the wearer with added strength, according to superstition. Doyle also painted African-Americans of national fame, such as Jackie Robinson and Ray Charles.

The artist's images generally focus on figures, providing a few props but very little environment. His paintings are remarkable because of his ability to keep his images so close to the surface, to the point where his large planes of flat color and dramatic line drawing almost become completely abstract. But Doyle magically holds his images together. Most of his existing work was made in the 1970s and early 1980s. The artist displayed his paintings against the side of his house, in his front yard, and nailed to trees: he conceived of his work as community art.

WILLIAM EDMONDSON

1870?–1951

TWO NURSES

ca. 1932–38

limestone

13 3/8 x 20 1/4 x 11 1/8 inches

The Newark Museum, Bequest of Edmund L. Fuller, Jr., 1985, 85.28

William Edmondson was one of six children born to former slaves who lived in Nashville. He was supposedly sixty-eight when he died in 1951, but family tradition places his birth in 1870. Edmondson's father died when he was young, and his mother supported the family by picking crops. Edmondson received little education, and when still quite young began working in the shop of the Nashville, Chattanooga and Saint Louis Railway. In 1907, a work-related injury forced him to leave the railroad company, and he found employment doing odd jobs at the Woman's Hospital. He left the hospital when it was closed in 1931.

At this point, he received a vision from God instructing him to carve in stone, something he had never done before. He fashioned his own tools, and working in limestone, began making tombstones and some garden sculpture. His clients initially came from the African-American community, many of them being fellow parishioners at the United Primitive Baptist Church. While some of the gravestones have designs incorporating triangles and circles that scholars feel relate to African traditions, many of the motifs are religious, and standard fare for memorial stones: angels, lambs, and doves.

Edmondson's style is quite simple. He worked with pure, smooth forms that followed horizontal or vertical planes, reflecting the block of stone from which they were carved. The power of his work lies in this simplicity, and in his ability to evoke the essence of his subject through a minimal number of moves.

In 1937, Edmondson's work was discovered and photographed by the *Harper's Bazaar* photographer Louise Dahl-Wolfe. She brought him to the attention of the staff of The Museum of Modern Art. In 1938, the museum's curator, Dorothy C. Miller, organized a one-person exhibition for him, which included twelve of his sculptures. He continued to work until four months before his death.

HISTORY OF PLANT FARM

MUSEUM — IT TOOK ME ABOUT SEVEN YEARS TO CLEAR OUT THIS JUNGLE KILLING OVER ONE HUNDRED SNAKES, AND CUTTING THOUSANDS OF TREES, BUSHES, VINES, AND THORNS, FILLING DITCHE, LEVELING CLEANING OUT GARBAGE THROUGHOUT, LABOR ALL BY HAND TOOLS, STANDING ON MUD PALETS RAKING OUT WATER WAYS FOR THREE SPRING BRANCHES. IT WAS SAID BY MRS. C.L. LOWERY THAT THIS PLACE ONCE WAS A LAKE WHERE MEN HUNTED DUCKS FROM SMALL ROWE BOATS, MR. C.L. LOWERY FORMER OWNER OF THIS LAND DUG INTO A CLAY POT OF INDIAN ARROW HEADS. IF HE FOUND OTHER THINGS IT.S, UNKNOWN, SINCE THAT TIME I FOUND ONE SMALL PIECE OF YELLOW GOLD SHINING FROM THE MUD WHERE I WAS DIGGING, NOT TOO FAR FROM THE CLAY POT, MR. LOWERY WAS A MUSIC TEACHER WROTE THE WORDS TO THE SONG LIFES EVENING SUN ALLSO STUDIED AND WORKED ON PREPITUAL MACHINE 40 YEARS, I NOW HAVE REMAINS OF HIS MACHINE, MANY YEARS AGO I KNOW GOD SPOKE TO MY SOUL THAT THERE WAS SOMETHING FOR ME IN PENNVILLE AFTER 40 YEARS PREACHING THE GOSPEL WITH OUT CHARGE, I THEN FELT LED TO BUILD A PARADISE GARDEN IN WHICH I WILL OPEN PRINT THE HOLY BIBLE VERSE BY VERSE, THROUGHOUT, PLEASE RESPECT FOR CHRIST SAKE. W.H.F.

HOWARD FINSTER

BORN 1915 OR 1916

HISTORY OF THE PLANT FARM

1982

enamel paint, pencil, and glitter on plywood

55 x 46 3/4 inches

Collection of Robert M. Greenberg

Photograph courtesy of Ricco/Maresca Gallery, New York

Howard Finster, the youngest of thirteen children, grew up on a forty-two-acre hog, corn, and pea-patch farm in Valley Head, Alabama. Because of the demands of the farm, he only attended school for six years. He became a born-again Christian at thirteen, and began preaching in Valley Head at the age of fifteen or sixteen. He was ordained as a Baptist minister shortly thereafter and wandered for over twenty-five years through rural Alabama and Georgia, preaching at tent revival meetings and hopping from one pastorship to another. He married in 1935. By the early 1960s, he was living in Pennville, Georgia, and pastoring at the Chelsea Baptist Church in nearby Menlo. At this point, Finster felt the need to make a garden for the Lord, and he began converting several acres of swamp behind his house into what he called the "Plant Farm Museum," later renamed "Paradise Garden." By the mid-1970s, the swamp was transformed into a garden filled with environmental sculpture, largely made of junk, and painted signs with biblical verses.

Toward 1976, Finster began painting, and he painted on anything: mostly plywood and heavy canvas, which he obtained at a local rug factory, but also Plexiglas, bottles, and televisions. Much of his work is religious, and, like his sermons, it presents apocalyptic scenes that admonish against a life of sin, together with heavenly visions that encourage dedication to the word of the Lord. His work has an intense, frenetic quality as brightly colored marks—figures, words, and details of all kinds—cover the surface of the images.

WILLIAM HAWKINS

1895–1990

JUKE BOX (MILLERS MAD)

1987

enamel paint, turntable, metal hardware, Miller Beer logo,
and other found objects on wood

62 1/2 x 50 1/2 inches

Collection of Gael Mendelsohn

Photograph courtesy of Ricco/Maresca Gallery, New York

Hawkins was born and raised in rural eastern Kentucky, near Lexington. He attended school for three years and worked on the family farm until 1916, when he fled to Columbus, Ohio, to escape what would have been literally a shotgun wedding. He served in France during World War I. After returning to Columbus, he married, had three children, got divorced, and remarried, all within ten years. A tireless worker, he held numerous odd jobs, often several at one time. For example, he tended horses for a milk company and drove a truck delivering coal. In addition to running his own small flophouse and collecting and selling scrap cardboard, which he did up to his death, he earned extra money by taking candid photograph portraits of his neighbors and making small drawings and paintings of subjects he thought would be popular and sell. These activities were begun at least by the 1930s.

Hawkins's earliest existing works are small-scale drawings and paintings made between 1975 and 1981 on discarded cardboard or heavy paper. After 1981, he became a prolific painter. He worked mostly on large pieces of Masonite, using enamel house paint, which he often found in the trash of a local hardware store. Hawkins was discovered by an artist, Lee Garrett, who lived nearby. Garrett encouraged Hawkins to enter his paintings in the 1982 Ohio State Fair, where one received an award. That same year, he was shown at the Ohio Gallery in Columbus, and the following year, he had a one-person exhibition at the Ricco-Johnson Gallery in New York City.

Hawkins's paintings are based on images taken from a large archive of reproductions he collected from magazines, books, and newspapers. Animals, buildings, and famous landmarks are among his best-known themes, but his subject matter is very diverse. Some works deal with serious concepts of family, nature, and the origins of the world, and some address racial issues. The strength of Hawkins's paintings lies in their breathtaking formal qualities: the lusciousness of his enamel, the wonderful manipulation of paint, the overall compositions, and the shifts in texture.

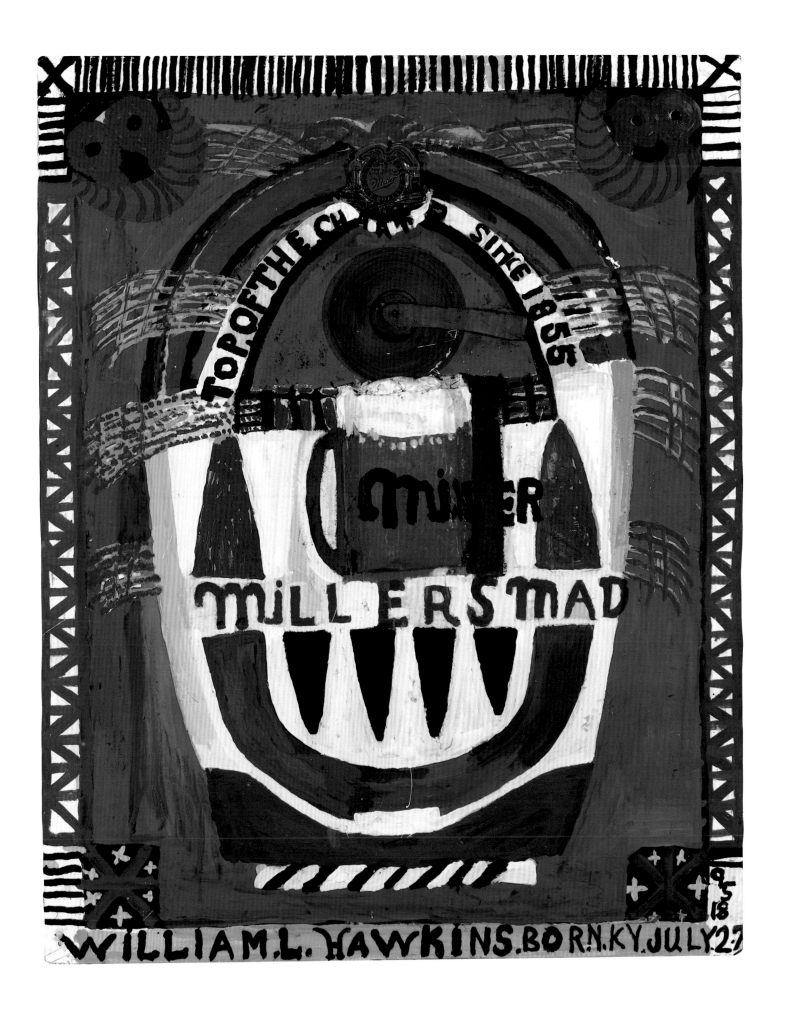

LAURA CRAIG McNELLIS

BORN 1957

UNTITLED (WHITE ARCH—DENTURES)

ca. 1982

mixed media on newsprint

20 x 28 inches

Collection of Roger Ricco

Photograph courtesy of Ricco/Maresca Gallery, New York

Laura McNellis is an artist who is mentally retarded, which in part accounts for her wonderful vision of the world around her. Her drawings are about her immediate life as represented by objects, such as her night-gown, her mother's dentures, the family refrigerator, toothpaste, a birthday cake, and a fish dinner. These motifs are presented in a restless cartoonish manner that animates them, pumping them up with life. Because she often presents a single motif pressed up to the surface of her image, she gives the object an emblematic presence. Often she abstracts her motif, rendering it virtually unrecognizable.

While she had painted since childhood, McNellis made the drawings for which she is now known from 1981 to 1991. She gradually stopped working when her home life changed due to a shift in family dynamics: her sisters left home and her parents became ill. She also took a job doing piecework at a New Horizons shel-tered workshop shortly before she quit painting. She has always lived with her parents in Nashville, briefly attending a school for the mentally disadvantaged when she was five and six, and special classes at public school between ages fifteen and eighteen. When she was young, her father, a postal worker who sorted mail, brought home blank newsprint, and she insisted on using this paper until she stopped painting, rejecting finer materials.

McNellis worked late at night, after everyone else went to bed. She usually clipped the corners off of the finished drawings, being careful not to remove too much of the sun that she regularly placed in the upper right-hand corner. Although she does not read or write, she would draw letters on one edge of the work, generally the bottom, sometimes punching out the centers of her *o*'s. When finished, the drawing was care-fully folded into fours and put into a pile in her room, where it would be forgotten. Of greater importance was the next drawing. McNellis also saved the empty paint containers, accumulating hundreds on the shelves in her room.

JOHN ("J.B.") MURRY

1908?–1988

UNTITLED

ca. 1980s

mixed media on paper

24 x 18 inches

Courtesy of Phyllis Kind Gallery, New York

66

J.B. Murry was born, raised, and lived in a rural community in Glascock County, near Sandersville, Georgia. Having no education, he earned a living as a sharecropper and a farmhand. He married and had eleven children, but separated from his wife in the 1950s or 1960s. In the late 1970s he became ill and stopped working. He had no income except a meager social-security check, and the electricity and running water in his shack were cut off. He began having visions and was briefly institutionalized.

At this point, Murry began making drawings—spirit scripts—the content of which was dictated directly to him by God. Murry was illiterate, and he claimed that God moved his hand and pencil. Although his drawings show little or no evidence of the process, he is said to have begun "writing" in the upper left-hand corner of the paper and to have proceeded to the right; on the next line he went from right to left, reversing the process on each line. Murray could "read" these spiritual messages by viewing the drawings through a glass of "holy" water taken from his well. Murry introduced evil spirits into his scriptures—ghostlike figures and faces. Some works were composed of just spirits and no writing.

The power of Murry's art lies in part in its abstraction; his religious intensity is condensed into a handful of colors and frenetic lines that are pressed to the surface of a spaceless composition. The light in his drawings sometimes has a mystical quality, due to the value or hue contrast of his paints with the white or colored paper, and because of his occasional use of a gold or silver color.

MARTIN RAMIREZ

1885?–1960

UNTITLED (CABALLERO WITH PALM TREES)

ca. 1954

ink, color pencil, and crayon on paper

48 x 36 inches

Collection of George and Sue Viener, courtesy of Janet Fleisher Gallery, Philadelphia

Photograph courtesy of Janet Fleisher Gallery, Philadelphia

In 1930, Martin Ramirez was picked up as an indigent by the Los Angeles police in Pershing Square. After several months of psychiatric examination, he was transferred to the De Witt State Hospital in Auburn. His illness was diagnosed as "paranoid schizophrenia, deteriorated," and he remained in the hospital until his death in 1960. The only biographical information that exists about him comes from Dr. Tarmo Pasto, a psychologist who befriended Ramirez in the late 1940s. According to Pasto, Ramirez was born in Jalisco, Mexico, where he worked as a laundryman. Poor and starving, he sought employment in California and was hired by the railway as a section hand. A small man, not able to deal with the heavy physical labor and the dramatic cultural transition, he became schizophrenic. At some point he became mute, only humming "in a sing-song way when pleased by visitors."

About 1948, Ramirez gave Pasto a drawing that he had hidden under his shirt. Apparently he had been drawing for some time, but hospital attendants had been destroying his work as he made it. Pasto encouraged Ramirez to draw as a form of therapy, and provided him with materials. In a typed handout entitled "Art from the Disturbed Mind," that accompanied a 1954 exhibition of nine of the artist's drawings at the Stanford Research Institute, Pasto described Ramirez's process:

> His manner of work is unique. When good paper is not available he glues together scraps of paper, old envelopes, paper bags, paper cups, wrappers—anything that may have a clear drawing area. He often makes many small background studies, sea shell and nature forms, which he stores in his shirt, in a paper shopping bag, in tied rolls, or behind a radiator, suddenly to be taken out and glued to an evolving picture. He fashions his own glue out of mashed potatoes and water—sometimes bread and water. He squats on his haunches, moving about the floor between two cots, using stubs of colored pencils and crayolas, drawing a little here, a little there. His drawing is kept rolled up and usually only a portion of it is exposed at any one time.

Ramirez's motifs were Mexican, American, and Catholic—caballeros, Madonnas, trains, cars, and animals. Because of his illness, it is difficult to read meaning into his drawings. The power of his work lies in the mysterious motifs and the haunting quality of its space, which is simultaneously flat and deep, and ultimately very claustrophobic—seemingly a reflection of his own state of mind.

JOHN SCHOLL

1827–1916

SUNBURST CELEBRATION

ca. 1913–16

paint on wood with string and metal

61 1/4 x 30 x 23 inches

The Newark Museum, Purchase, 1991, The Members' Fund, 91.291

John Scholl was a German immigrant who arrived in New York City with his fiancée in 1853. Shortly there-after, he married and moved to Schuylkill County, Pennsylvania, the heart of coal country, where he worked as a carpenter, building houses and colliery scaffolding for a mining company. Scholl was naturalized in 1860, and by 1870 had moved to the German community of Germania, Pennsylvania, where he bought a farm that eventually grew to 157 acres. He built a large Victorian-style house on his property and decorated it heavily with gingerbread trim.

Scholl is said to have begun whittling about 1907. At first, he made whittler's puzzles, complex works carved from a single piece of wood, such as chains or a ball in a cage. Gradually, he started making wood toys, many with mechanical parts. Next he made small flat works he called "snowflakes," which eventually evolved into large freestanding works that came to be called "celebrations" after his death. All told, Scholl made forty-seven works, which he displayed in his parlor. As word spread about this unusual exhibit, people flocked to his house, and he was forced to establish exhibition hours on Sundays. He gave tours, explaining the personal meaning of each work. After his death, his son John continued the tours until the 1930s.

Scholl's inspiration for the "snowflakes" and "celebrations" came from Victorian gingerbread house trim, in which he was expert. His genius lay in transforming a decorative tradition into full-blown sculpture. Embedded in many of these works are German crosses, doves, and tulip shapes, which were derived from German folk art. Some of the "celebrations," such as *Sunburst Celebration*, are mechanized, like some of Scholl's toys. A crank, pulleys, and string allow the "snowflakes" or "sunbursts" to turn. However, many of the "celebrations" are so anthropomorphic that they suggest female figures, a concept that paralleled the machine figures being made by Francis Picabia and Marcel Duchamp at exactly the same time.

BILL TRAYLOR

1854–1947

WOMAN HOLDING UMBRELLA

ca. 1939–42

pencil and poster paint on cardboard

12 3/4 x 11 inches

Courtesy of Luise Ross Gallery, New York

Bill Traylor was born a slave on the George Traylor plantation, just outside of Benton, Alabama. Upon emancipation, he took the name of his owner, and stayed on at the plantation as a field hand. He married and had twenty-two children. Sometime between 1936 and 1938, Traylor moved to Montgomery. His wife was dead, the plantation owner's immediate family was gone, and his children had scattered. He worked briefly in a shoe factory, but left due to illness and went on welfare. He slept in the back of a funeral home, then in a shoe-repair shop. During the day, he sat on a box on a Monroe Street sidewalk, protected by the overhang of a fruit-stand shed which was located next to the rear entrance of a pool hall. Here, he began to make drawings, with a board placed across his lap for a "table." He stopped drawing in 1942 when he went to Detroit and then Washington to live with his children. He returned to Montgomery in 1946, and died the following year.

In three years, Traylor produced roughly 1,200 drawings. He used pencil on found cardboard, until he was discovered by a local artist, Charles Shannon, who brought him poster paint and paper. His subject matter was the rural world in which he had spent his life: local personalities, animals, farming, and hunting, for example. His vision, however, gave a demonic twist to this agrarian environment: his running animals appear to be fleeing, or attacking one another or humans; people are often missing limbs or are drinking alcohol. A mood of hysteria and chaos generally reigns, although it is often mitigated by a comic sensibility.

EUGENE VON BRUENCHENHEIN

1910–1983

UNTITLED (NO. 570)

1957

oil on Masonite

24 1/16 x 24 1/16 inches

John Michael Kohler Arts Center, Sheboygan, Wisconsin

Eugene Von Bruenchenhein was born to middle-class parents in Marinette, Wisconsin. The family moved to Green Bay and then to Milwaukee when he was young. His father, a sign painter, opened a small grocery store in the front of the family home, where the son would eventually live with his wife. Von Bruenchenhein first worked for a florist, then at a bakery where he stayed until retiring in 1959. He appeared to lead an uneventful working-class life. Upon his death in 1983, however, he left a legacy of thousands of paintings, sculptures, and photographs, along with volumes of poetry. Only a handful of friends and relatives knew about this vast body of work.

Von Bruenchenhein probably learned to paint from his stepmother, who made still lifes of flowers. She was also a writer who published treatises on evolution. The paintings for which Von Bruenchenhein has become best known were begun in 1954 in reaction to the dropping of the hydrogen bomb. The first work depicted the explosion of the bomb. The following works were lush portrayals of exotic fantasy plants and landscapes, where nature was out of control. Monsters sometimes populate these hallucinatory worlds, and the plants themselves seem to be transformed into threatening creatures.

Von Bruenchenhein worked in oil, most often on Masonite. He manipulated the paint with his fingers and a variety of objects, but he preferred to use brushes made from the hair of his wife, Marie, with whom he was obsessed. Beginning in the 1940s, he photographed her in pinup poses thousands of times. He also worked in ceramic, making crowns and grotesque heads and faces that had the same botanical elements found in the paintings. Another medium he worked in was chicken bones. The bones were assembled into tiny chairs on the scale of dollhouse furniture, and have the same foreboding quality found in the paintings.

JOSEPH YOAKUM

1886/88–1972

RED MTN AND RED CLAY PASS IN SAN JUAN RANGE NEAR TELLURIDE COLORADO

n.d.

color pencil, watercolor, and ballpoint pen on paper

19 x 12 inches

Collection of Jill and Sheldon Bonovitz, courtesy of Janet Fleisher Gallery, Philadelphia

Photograph courtesy of Janet Fleisher Gallery, Philadelphia

Joseph Yoakum was born in Window Rock, in the Navajo Nation in Arizona. He was part African-American and part "Nava-joe," as he described himself. At some point, his family moved to Missouri. When he was in his early teens, he ran away from home to join the circus, and he claimed to have worked for the Adam Forbaugh, Buffalo Bill, and Ringling Brothers circuses, even serving as personal valet to John Ringling himself. He apparently had a lust for travel, and he literally worked his way around the world as a sailor or railway porter, or was simply a vagabond. Even before serving in France during World War I, he boasted that he had set foot on every continent except Antarctica. He married in 1910 and again in 1929, fathering five children. Yoakum settled in Chicago in the early 1950s, and supposedly opened a small ice cream parlor with his second wife.

In 1962, after the death of his wife, Yoakum began making drawings, almost all landscapes. He used pencil, ballpoint and felt-tip pens, pastels, and watercolors on paper. He claimed to have been to all of the places in his works, and carefully identified each scene with an inscription on the front of the drawing. Many of his works are dated with a date stamp. While he owned an *Encyclopedia Britannica*, an atlas, and some travel books, he told everyone that he made his drawings using the process of "spiritual enfoldment," the meaning of which is unclear. In 1966, he moved out of a housing project into a former barbershop on Chicago's South Side, hanging his drawings in the window in the hope of making sales.

Although Yoakum's world travels took him to cities and towns, his drawings focus on landscape. His interest is in nature—mountains, water, sky, trees, flowers, and plains—and his drawings are about these qualities and not specific sites, despite the titles of the works. He developed an abstract vocabulary to represent nature, a kind of sign language for water, mountains, and trees. This abstraction takes over his compositions, its organic, mysterious undulation seeming to stand for the elemental forces found in nature.

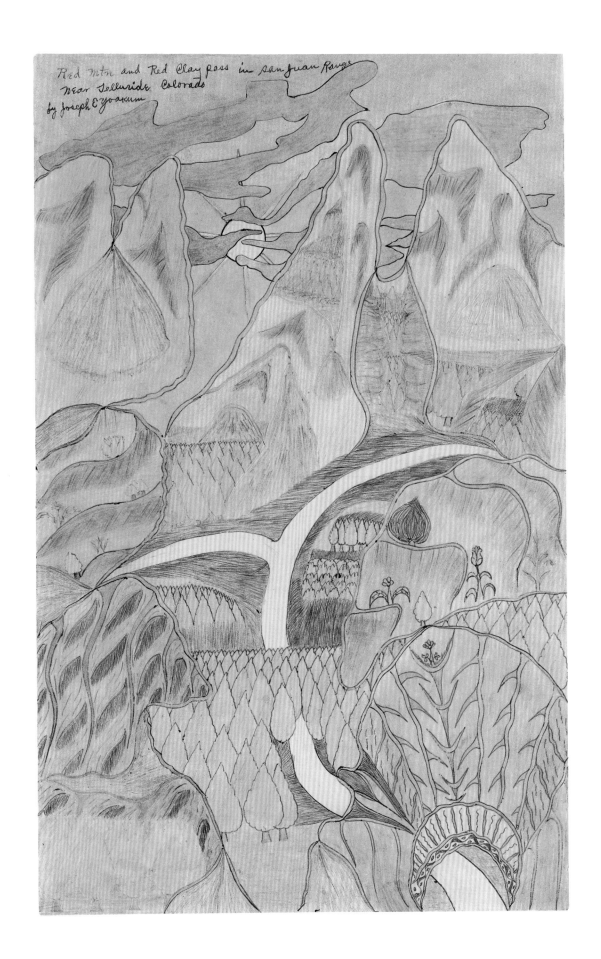

Red Mtn and Red Clay pass in San Juan Range
near Telluride Colorado
by Joseph E Yoakum

PURVIS YOUNG

BORN 1943

UNTITLED (FIVE LARGE FIGURES)

1987

60 x 48 inches

mixed media on board

Private collection, courtesy of Ricco/Maresca Gallery, New York

Photograph courtesy of Ricco/Maresca Gallery, New York

Purvis Young was born and raised in Miami's inner city, Overtown. From ages eighteen to twenty-one, he was incarcerated in Florida's Raiford Prison, serving time for armed robbery. There he took an art class. He became committed to making art in the late 1960s, when he was flipping through a book and came across illustrations of the Wall of Respect, the famous Chicago mural depicting African-American leaders on the side of a South Side building. Young had strong feelings about his community and decided to express them through paintings on buildings. Using house paint on found plywood, he made hundreds of pictures about the community, which he began nailing to boarded-up buildings on a segment of Overtown's Fourteenth Street called Good Bread Alley.

The images in Young's paintings depict street life, but in an abstract style. Figures are reduced to single dramatic abstract expressionist brushstrokes, and buildings to rectangular shapes. Over the years, his work has depicted pregnant women, funerals, and basketball players. Large eyes, symbols of the establishment, often float in his pictures. Trucks, which can be seen on the interstate that cuts through Overtown, represent products and material wealth that go elsewhere. Horses represent freedom. The large heads that float over his scenes symbolize leadership.

Beginning in the 1980s, Young began making crude frames out of disparate pieces of discarded wood. Much of the power of his art lies in his ability to integrate the actual refuse of his community into his work. Young paints on doors, desk drawers, and mirrors—whatever he finds in the trash. He also retrieves books thrown away by the local library, and pastes his drawings into them. The community is not only represented in the drawn buildings and people, but it is also actually present in the material itself.

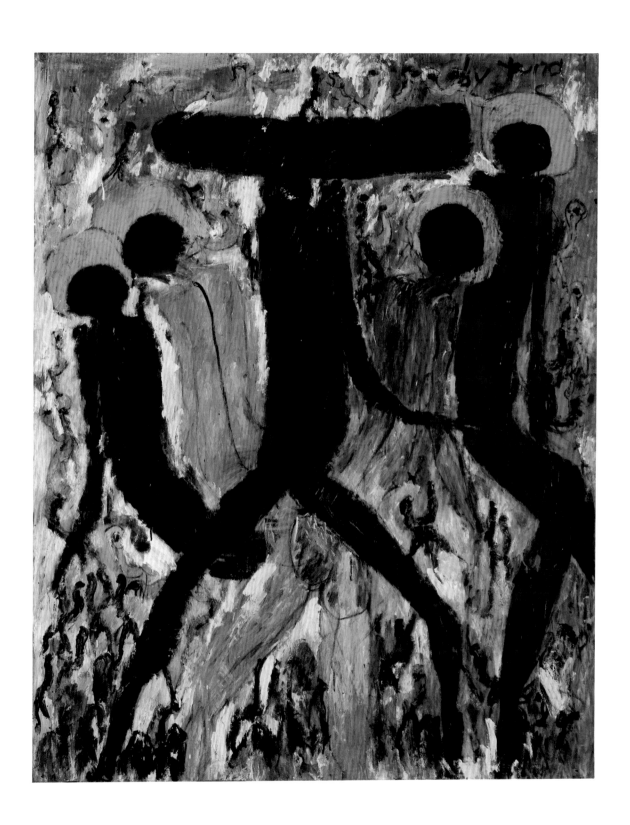

WILLIE WAYNE YOUNG

BORN 1942

UNTITLED

1977

pencil on white paper

24 x 18 inches

Private collection, courtesy of Ricco/Maresca Gallery, New York

Photograph courtesy of Ricco/Maresca Gallery, New York

Willie Young was born into a poor Dallas family. At age fifteen, he took an art course by mail. At sixteen, he was sentenced to a juvenile home, where he was encouraged to draw by his counselor; as a teenager, Young was in and out of juvenile homes for several offenses. He attended Lincoln High School, where his drawing talent was recognized, and he received a scholarship for a Saturday morning class at the art school of the Dallas Museum of Art. His teacher, Chapman Kelly, encouraged him to follow his own course of study rather than the standard curriculum. Despite a high-school education, Young is illiterate, and has worked his entire life shining shoes in a barber shop. Between customers, he makes his drawings, all graphite on paper.

Young's images are derived from either plants or small bird and animal bones, which he transforms into suggestive organic objects with no particular identity. His pictures are haunting, not only because of the puzzling nonspecificity of his images, but also because of the way in which they mysteriously float on the white field of the paper. The delicacy of the drawing technique, which gives the "plants" and "bones" a fragile, ephemeral quality, further adds to the powerful eeriness of the works.

Despite his art courses and connections to trained artists, Young is still a "self-taught" artist, and his art closely follows the pattern of most in this category: he has a single theme, which he has been compulsively repeating for the last thirty years, and he makes no attempt to show or sell his art—he simply stores his daily production in his bedroom. Like many self-taught artists who have received a minimal amount of formal instruction or have seen some fine art, he shows little or no impact from these experiences in his vision. Young remains focused on his own concerns, not those of the art world.

LENDERS TO THE EXHIBITION

William Arnett

Yosi Barzilai

Edward V. Blanchard and M. Anne Hill

Jill and Sheldon Bonovitz

Peter S. Brams

Sam and Betsy Farber

Janet Fleisher Gallery, Philadelphia

Robert M. Greenberg

Carl Hammer Gallery, Chicago

Herbert Waide Hemphill, Jr.

Chapman Kelly

Phyllis Kind

Phyllis Kind Gallery, New York

John Michael Kohler Arts Center, Sheboygan, Wisconsin

Dr. and Mrs. Richard U. Levine

Frank Maresca

Mark Mainwaring

Gael Mendelsohn

Museum of American Folk Art, New York

The Newark Museum

New York State Historical Association, Cooperstown, New York

Gladys Nilsson and Jim Nutt

Ann and John Ollman

David T. Owsley

Roger Ricco

Ricco / Maresca Gallery, New York

Luise Ross Gallery, New York

Mr. and Mrs. Selig D. Sacks

George and Sue Viener

Whitney Museum of American Art, New York

And those who have preferred to remain anonymous.

WORKS IN THE EXHIBITION

A WORLD OF THEIR OWN

TWENTIETH-CENTURY AMERICAN FOLK ART

Dimensions are in inches, in the following order: height, width, depth.

ARTIST UNKNOWN ("PHILADELPHIA WIREMAN")

Untitled, ca. 1960s–70s, mixed-media assemblage, 171/2 x 51/8 x 43/4, The Newark Museum, Purchase, 1992, Eleanor S. Upton Bequest Fund, 92.21

Untitled, ca. 1960s–70s, mixed-media assemblage, 77/8 x 21/8 x 17/8, The Newark Museum, Purchase, 1992, Eleanor S. Upton Bequest Fund, 92.22

Untitled, ca. 1960s–70s, mixed-media assemblage, 43/8 x 21/2 x 13/4, The Newark Museum, Purchase, 1992, Eleanor S. Upton Bequest Fund, 92.23

Untitled, ca. 1960s–70s, mixed-media assemblage, 37 x 8 x 2, collection of Ann and John Ollman, Philadelphia

Untitled, ca. 1960s–70s, mixed-media assemblage, 6 x 41/2 x 4, collection of Ann and John Ollman, Philadelphia

Untitled, ca. 1960s–70s, mixed-media assemblage, 5 x 5 x 31/2, courtesy of Janet Fleisher Gallery, Philadelphia

Untitled, ca. 1960s–70s, mixed-media assemblage, 8 x 41/2 x 21/2, courtesy of Janet Fleisher Gallery, Philadelphia

Untitled, ca. 1960s–70s, mixed-media assemblage, 41/4 x 31/4 x 21/2, courtesy of Janet Fleisher Gallery, Philadelphia

Untitled, ca. 1960s–70s, mixed-media assemblage, 41/4 x 21/2 x 21/2, collection of Mark Mainwaring, El Paso, Texas

Untitled, ca. 1960s–70s, mixed-media assemblage, 53/4 x 2 x 13/4, courtesy of Janet Fleisher Gallery, Philadelphia

Untitled, ca. 1960s–70s, mixed-media assemblage, 71/2 x 21/4 x 11/2, courtesy of Janet Fleisher Gallery, Philadelphia

Untitled, ca. 1960s–70s, mixed-media assemblage, 4 x 21/2 x 1, courtesy of Janet Fleisher Gallery, Philadelphia

Untitled, ca. 1960s–70s, mixed-media assemblage, 31/2 x 21/2 x 2, courtesy of Janet Fleisher Gallery, Philadelphia

Untitled, ca. 1960s–70s, mixed-media assemblage, 43/4 x 31/2 x 21/2, courtesy of Janet Fleisher Gallery, Philadelphia

Untitled, ca. 1960s–70s, mixed-media assemblage, 3 x 11/2 x 11/2, collection of Mark Mainwaring, El Paso, Texas

Untitled, ca. 1960s–70s, mixed-media assemblage, 61/2 x 41/4 x 2, collection of Mark Mainwaring, El Paso, Texas

Untitled, ca. 1960s–70s, mixed-media assemblage, 41/2 x 31/2 x 21/2, courtesy of Janet Fleisher Gallery, Philadelphia

Untitled, ca. 1960s–70s, mixed-media assemblage, 33/4 x 3 x 1, courtesy of Janet Fleisher Gallery, Philadelphia

Untitled, ca. 1960s–70s, mixed-media assemblage, 33/4 x 3 x 1/2, courtesy of Janet Fleisher Gallery, Philadelphia

Untitled, ca. 1960s–70s, mixed-media assemblage, 3 x 2 x 11/2, courtesy of Janet Fleisher Gallery, Philadelphia

ARTIST UNKNOWN ("MASTER OF THE WOODBRIDGE FIGURES")

Untitled, ca. 1940s–50s, polychromed wood, 50 figures, ranging in size from 41/2 to 73/4 high, collection of Gael Mendelsohn, Hastings-on-Hudson, New York

WILLIAM ALVIN BLAYNEY

Anti-Christ Kingdom, 1961, oil on canvas on board, 24 x 18, courtesy of Phyllis Kind Gallery, New York

Lord's Prayer, 1980, oil and sand on board, 33 x 27, courtesy of Phyllis Kind Gallery, New York

Chart of Eight Dispensations of Ages, 1972, oil and pencil on board, 473/4 x 24, courtesy of Phyllis Kind Gallery, New York

Mural of Combined Prophecies of Figures and Symbols of the Books of Daniel and Revelation of the Holy Bible, 1956, oil on Masonite, 481/4 x 343/8, collection of David T. Owsley, New York

The Four Winds, 1960, oil on Masonite, 24 x 311/2, collection of David T. Owsley, New York

Panel: Revelation Mural, 1969, oil and pencil on board, 24 x 26, collection of Herbert W. Hemphill, Jr., New York

DAVID BUTLER

Fish, ca. 1970s, cut and painted tin with wire and wood, 16 x 191/2 x 2, The Newark Museum, Bequest of Edmund L. Fuller, Jr., 1985, 85.415

Stork with Baby, ca. 1970s, cut and painted tin with wire and buttons, 151/2 x 291/4 x 14, The Newark Museum, Bequest of Edmund L. Fuller, Jr., 1985, 85.416

The Nativity, ca. 1970s, cut and painted tin with wire, 273/4 x 361/2 x 21/2, The Newark Museum, Bequest of Edmund L. Fuller, Jr., 1985, 85.421

Wise Man, ca. 1970s, cut and painted tin with wire and plastic, 241/2 x 251/2 x 1, The Newark Museum, Bequest of Edmund L. Fuller, Jr., 1985, 85.422

Wise Man, ca. 1970s, cut and painted tin with wire and plastic, 261/2 x 29 x 11/2, The Newark Museum, Bequest of Edmund L. Fuller, Jr., 1985, 85.423

Bird, ca. 1970s, cut and painted tin with wire and plastic, 14 x 25 x 14, The Newark Museum, Bequest of Edmund L. Fuller, Jr., 1985, 85.525

Double-Headed Rooster, ca. 1970s, cut and painted tin with wire and wood, 13 x 13 x 71/2, The Newark Museum, Bequest of Edmund L. Fuller, Jr., 1985, 85.426

Parrot, ca. 1970s, cut and painted tin with wire, 101/2 x 151/2 x 14, The Newark Museum, Bequest of Edmund L. Fuller, Jr., 1985, 85.427

Double Man, ca. 1970s, cut and painted tin with wire, plastic, and wood, 101/2 x 18 x 2, The Newark Museum, Bequest of Edmund L. Fuller, Jr., 1985, 85.429

Centaur, ca. 1970s, cut and painted tin with wire and plastic, 25 x 29 x 11/4, The Newark Museum, Bequest of Edmund L. Fuller, Jr., 1985, 85.430

Whirligig with Winged Donkey, ca. 1970s, cut and painted tin with wood, wire, plastic, and metal rod, 191/2 x 341/2 x 21, The Newark Museum, Bequest of Edmund L. Fuller, Jr., 1985, 85.433

Whirligig with Rooster and Man, ca. 1970s, cut and painted tin with wood, wire, plastic, and metal rod, 22 x 40 x 241/2, The Newark Museum, Bequest of Edmund L. Fuller, Jr., 1985, 85.434

Peacock Whirligig, ca. 1970s, cut and painted tin with wood, wire, plastic, and metal rod, 22 x 40 x 241/2, The Newark Museum, Bequest of Edmund L. Fuller, Jr., 1985, 85.435

HENRY DARGER

Draw Drops on Water, n.d., watercolor, pencil, and collage on paper, 24 x 54, collection of Yosi Barzilai, New York

At Battle Near McHollester Run, n.d., watercolor and pencil on paper, 19 x 48, collection of Herbert W. Hemphill, Jr., New York

Untitled, n.d., mixed media on paper, 181/2 x 231/2, collection of Sam and Betsy Farber, New York

They Are Shooting at Enemy Soldiers/At Mt. Halleston, n.d., watercolor, pencil, and carbon tracing on paper, 18 x 48, collection of Sam and Betsy Farber, New York

After McWhirther Run Glendelinians Attack and Blow Up Train, n.d., collage, watercolor, poster paint, pencil, and carbon tracing on paper, 23 x 361/2, collection of Sam and Betsy Farber, New York

The Blengiglomenean Called a Crimerceïan Venemous, n.d., pencil and watercolor on paper, 19 x 24, collection of Sam and Betsy Farber, New York

At Collis Junction/After Leaving Cavern, n.d., collage, pencil, and carbon tracing on paper, 18 x 70, collection of Sam and Betsy Farber, New York

Escape Them by a Clever Run, n.d., watercolor and pencil on paper, 23 x 853/4, collection of Robert M. Greenberg, New York

THORNTON DIAL, SR.

Knowing the Road, 1993, mixed media on board, 56 x 78 x 6, courtesy of Phyllis Kind Gallery, New York

The Reservoir, 1990, oil on canvas, 71 x 96, collection of David T. Owsley, New York

Every Year Carries a Number (Old Life Recycling), 1993, mixed media on board, 72 x 60 x 8, collection of William Arnett, Atlanta

SAM DOYLE

Larie Rivers (Basketball Player), n.d., house paint on tin, 371/2 x 251/2, courtesy of Ricco/Maresca Gallery, New York

Hit Ya' Man, n.d., house paint on tin, 551/2 x 25, courtesy of Ricco/Maresca Gallery, New York

Edi Singleton, n.d., house paint on tin, 48 x 27, collection of Gael Mendelsohn, Hastings-on-Hudson, New York

Uncle Remus, 1982, paint on window shade, 67 x 341/2, collection of Gael Mendelsohn, Hastings-on-Hudson, New York

Adlade, n.d., house paint on tin, 54 x 38, collection of Dr. and Mrs. Richard U. Levine, Englewood, New Jersey

WILLIAM EDMONDSON

Preacher, ca. 1930s–40s, limestone, 163/8 x 81/2 x 63/4, The Newark Museum, Bequest of Edmund L. Fuller, Jr., 1985, 85.16

Jack Johnson, ca. 1930s–40s, limestone, 163/16 x 8 x 8, The Newark Museum, Bequest of Edmund L. Fuller, Jr., 1985, 85.18

Ram, ca. 1930s, limestone, 141/2 x 18 x 51/2, The Newark Museum, Bequest of Edmund L. Fuller, Jr., 1985, 85.20

Bird, ca. 1930s–40s, limestone, 63/4 x 111/4 x 3, The Newark Museum, Bequest of Edmund L. Fuller, Jr., 1985, 85.22

Bird, ca. 1930s–40s, limestone, 61/2 x 16 x 31/4, The Newark Museum, Bequest of Edmund L. Fuller, Jr., 1985, 85.23

Bird, ca. 1930s–40s, limestone, 61/2 x 123/4 x 5, The Newark Museum, Bequest of Edmund L. Fuller, Jr., 1985, 85.24

Two Doves, ca. 1930s–40s, limestone, 8 x 9 x 51/2, The Newark Museum, Bequest of Edmund L. Fuller, Jr., 1985, 85.25

Pig, ca. 1930s–40s, limestone, 121/4 x 113/8 x 43/4, The Newark Museum, Bequest of Edmund L. Fuller, Jr., 1985, 85.26

Two Nurses, ca. 1932–38, limestone, 133/8 x 201/4 x 111/8, The Newark Museum, Bequest of Edmund L. Fuller, Jr., 1985, 85.28

Angel, ca. 1932–38, limestone, 245/8 x 141/8 x 61/2, The Newark Museum, Bequest of Edmund L. Fuller, Jr., 1985, 85.30

Seated Female Nude, ca. 1930s–40s, limestone, 273/8 x 101/2 x 121/4, The Newark Museum, Bequest of Edmund L. Fuller, Jr., 1985, 85.31

Seated Girl with Legs Folded, ca. 1930s–40s, limestone, 213/4 x 163/4 x 107/8, The Newark Museum, Bequest of Edmund L. Fuller, Jr., 1985, 85.32

The Lawyer, 1930s–40s, limestone, 261/2 x 111/16 x 67/8, The Newark Museum, Bequest of the Estate of Margaret L. Meiss, with the concurrence of her daughter Elinor M. Siner, 1994, 94.215

HOWARD FINSTER

Clock, n.d., paint and carving on plywood, 81 x 23, collection of Gael Mendelsohn, Hastings-on-Hudson, New York

Vision of Heaven's West Wing, 1984, mixed-media assemblage, 28 x 20 x 31/2, collection of Gael Mendelsohn, Hastings-on-Hudson, New York

He that Ploweth Iniquity Shall Reap the Same, 1982, enamel paint on wood, 131/2 x 171/2, courtesy of Phyllis Kind Gallery, New York

Weight of the World, 1982, enamel paint on plywood, 18 x 443/8, collection of Robert M. Greenberg, New York

History of the Plant Farm, 1982, enamel paint, pencil, and glitter on plywood, 55 x 463/4, collection of Robert M. Greenberg, New York

The New Phyllis Kind Dollar, 1980, enamel paint on wood, 301/2 in diameter, collection of Phyllis Kind, New York

WILLIAM L. HAWKINS

Juke Box (Millers Mad), 1987, paint, turntable, metal hardware, Miller Beer logo, and other found objects on wood, 621/2 x 501/2, collection of Gael Mendelsohn, Hastings-on-Hudson, New York

Tiger and Bear, 1989, mixed media on Masonite, 42 x 48, courtesy of Ricco/Maresca Gallery, New York

Red Dog Running, 1983, mixed media on plywood, 401/2 x 49, collection of Roger Ricco, New York

First Ferris Wheel No. 2, 1985, enamel paint on Masonite, 57 x 47, collection of Frank Maresca, New York

LAURA CRAIG McNELLIS

Untitled (White Arch—Dentures), ca. 1982, mixed media on newsprint, 20 x 28, collection of Roger Ricco, New York

Untitled (Dinner White Plate), ca. 1982, mixed media on newsprint, 21 x 281/2, courtesy of Ricco/Maresca Gallery, New York

Untitled (White Bed), ca. 1982, mixed media on newsprint, 20 x 28, collection of Roger Ricco, New York

Untitled (Red, Green Triangles), ca. 1982, mixed media on newsprint, 20 x 28, collection of Frank Maresca, New York

Untitled (Kitchen Stove), ca. 1982, mixed media on newsprint, 20 x 28, courtesy of Ricco/Maresca Gallery, New York

Untitled (Red, White, Blue), ca. 1982, mixed media on newsprint, 20 x 28, courtesy of Ricco/Maresca Gallery, New York

Untitled (Birthday Cake), ca. 1982, mixed media on newsprint, 20 x 28, courtesy of Ricco/Maresca Gallery, New York

Untitled (Refrigerator), ca. 1982, mixed media on newsprint, 20 x 28, courtesy of Ricco/Maresca Gallery, New York

Untitled (Nightgown), ca. 1982, mixed media on dress pattern paper, 21 x 271/2, collection of Gael Mendelsohn, Hastings-on-Hudson, New York

JOHN ("J.B.") MURRY

Untitled, ca. 1980s, mixed media on paper, 14 x 11, courtesy of Phyllis Kind Gallery, New York

Untitled, ca. 1980s, mixed media on paper, 14 x 11, courtesy of Phyllis Kind Gallery, New York

Untitled, ca. 1980s, mixed media on paper, 14 x 11, courtesy of Phyllis Kind Gallery, New York

Untitled, ca. 1980s, mixed media on paper, 14 x 11, courtesy of Phyllis Kind Gallery, New York

Untitled, ca. 1980s, mixed media on paper, 14 x 11, courtesy of Phyllis Kind Gallery, New York

Untitled, ca. 1980s, mixed media on paper, 24 x 18, courtesy of Phyllis Kind Gallery, New York

Untitled, ca. 1980s, mixed media on paper, 24 x 18, courtesy of Phyllis Kind Gallery, New York

Untitled, ca. 1980s, mixed media on paper, 24 x 18, courtesy of Phyllis Kind Gallery, New York

Untitled, ca. 1980s, mixed media on paper, 24 x 18, courtesy of Phyllis Kind Gallery, New York

Untitled, ca. 1980s, mixed media on paper, 24 x 18, courtesy of Phyllis Kind Gallery, New York

Untitled, ca. 1980s, mixed media on paper, 24 x 18, courtesy of Phyllis Kind Gallery, New York

Untitled, ca. 1980s, mixed media on paper, 14 x 11, courtesy of Phyllis Kind Gallery, New York

Untitled, ca. 1980s, mixed media on paper, 14 x 11, courtesy of Phyllis Kind Gallery, New York

Untitled, ca. 1980s, mixed media on paper, 14 x 11, courtesy of Phyllis Kind Gallery, New York

Untitled, ca. 1980s, mixed media on paper, 14 x 11, courtesy of Phyllis Kind Gallery

Untitled, ca. 1980s, mixed media on paper, 14 x 11, courtesy of Phyllis Kind Gallery, New York

Untitled, ca. 1980s, mixed media on paper, 14 x 11, courtesy of Phyllis Kind Gallery, New York

Untitled, ca. 1980s, mixed media on paper, 14 x 11, courtesy of Phyllis Kind Gallery, New York

Untitled, ca. 1980s, mixed media on paper, 14 x 11, courtesy of Phyllis Kind Gallery, New York

Untitled, ca. 1980s, mixed media on paper, 14 x 11, courtesy of Phyllis Kind Gallery, New York

Untitled, ca. 1980s, mixed media on paper, 14 x 11, courtesy of Phyllis Kind Gallery, New York

Untitled, ca. 1980s, mixed media on paper, 14 x 11, courtesy of Phyllis Kind Gallery, New York

Untitled, ca. 1980s, mixed media on paper, 14 x 11, courtesy of Phyllis Kind Gallery, New York

MARTIN RAMIREZ

Untitled (Alamentosa), ca. 1950s, pencil and paint on paper, 801/4 x 341/2, collection of Gladys Nilsson and Jim Nutt, courtesy of Janet Fleisher Gallery, Philadelphia

Untitled (Caballero with Palm Trees), ca. 1950s, ink, color pencil, and crayon on paper, 48 x 36, collection of George and Sue Viener, courtesy of Janet Fleisher Gallery, Philadelphia

Untitled (Skeleton Scroll), ca. 1950s, pencil and crayon on paper, 811/2 x 35, courtesy of Phyllis Kind Gallery, New York

Untitled (Three Buses), ca. 1950s, mixed media on paper, 223/4 x 293/4, collection of Edward V. Blanchard and M. Anne Hill, New York

JOHN SCHOLL

Sunburst, ca. 1907–16, wood, paint, and metal wire, 71 x 38 x 241/2, Museum of American Folk Art, New York, Gift of Cordelia Hamilton

Flowering Circle, c. 1907–16, painted wood, 77 x 22 x 22, collection of the Whitney Museum of American Art, Purchased with funds from the Howard and Jean Lipman Foundation, Inc., 68.22

Mary's Star, 1907–16, painted wood, 683/4 x 22 x 30, collection of the New York State Historical Association, Cooperstown

Sunburst Celebration, ca. 1913–16, paint on wood with string and metal, 611/4 x 30 x 23, The Newark Museum, Purchase, 1991, The Members' Fund, 91.291

BILL TRAYLOR

Untitled (Brown Goat), ca. 1939–42, pencil and poster paint on cardboard, 12 x 101/8, The Newark Museum, Purchase, 1982, Felix Fuld Bequest Fund, 82.121

Untitled (Man in Blue Shirt), ca. 1939–42, pencil and poster paint on cardboard, 141/2 x 111/2, The Newark Museum, Purchase, 1982, Felix Fuld Bequest Fund, 82.122

Untitled (Iconic Shovel Man—Bottle with Head Stopper), ca. 1939–42, pencil and poster paint on cardboard, 10 x 91/2, courtesy of Ricco/Maresca Gallery, New York

Untitled (Snake), ca. 1939–42, poster paint on cardboard, 131/4 x 26, courtesy of Luise Ross Gallery, New York

Untitled (Man in Black Pants), ca. 1939–42, pencil and poster paint on cardboard, 131/2 x 103/4, courtesy of Luise Ross Gallery, New York

Untitled (Lamps on Mantlepiece), ca. 1939–42, poster paint on cardboard, 103/4 x 71/2, courtesy of Luise Ross Gallery, New York

Untitled (Figure and Dog Outside House), ca. 1939–42, pencil and poster paint on cardboard, 14 x 22, courtesy of Luise Ross Gallery, New York

Untitled (Woman Holding Umbrella), ca. 1939–42, pencil and poster paint on cardboard, 123/4 x 11, courtesy of Luise Ross Gallery, New York

Untitled (Preacher and Congregation), ca. 1939–42, pencil and color pencil on cardboard, 161/2 x 161/2, collection of Gael Mendelsohn, Hastings-on-Hudson, New York

Untitled (Figures, Animals and Bird on Structure), ca. 1939–42, pencil and poster paint on cardboard, 113/4 x 111/2, collection of Gael Mendelsohn, Hastings-on-Hudson, New York

Untitled (Running Dog), ca. 1939–42, poster paint on cardboard, 141/2 x 15, collection of Frank Maresca, New York

Untitled (Running Rabbit), ca. 1939–42, pencil and poster paint on cardboard, 141/2 x 221/2, collection of Edward V. Blanchard and M. Anne Hill, New York

Untitled (Construction with Three Figures), ca. 1939–42, poster paint on cardboard, 15 1/2 x 10, collection of Edward V. Blanchard and M. Anne Hill, New York

Untitled (Tree with Figures and Animals), ca. 1939–42, pencil on cardboard, 22 x 14, collection of Peter S. Brams, Guttenberg, New Jersey

Chicken Stealing, ca. 1939–42, pencil on cardboard, 21 3/4 x 14, collection of Peter S. Brams, Guttenberg, New Jersey

Untitled (Man with Cane and Dog), ca. 1939–42, pencil and charcoal on pressed cardboard, 14 x 7, private collection, New York, courtesy of Ricco/Maresca Gallery, New York

EUGENE VON BRUENCHENHEIN

Fantasia Imperalis, 1954, oil on corrugated cardboard, 33 1/2 x 33 13/16, John Michael Kohler Arts Center, Sheboygan, Wisconsin

Untitled (No. 410), 1956, oil on paper, 17 x 15, collection of Edward V. Blanchard and M. Anne Hill, New York

Untitled (No. 570), 1957, oil on Masonite, 24 1/16 x 24 1/16, John Michael Kohler Arts Center, Sheboygan, Wisconsin

Untitled (Wand of the Genii Series, No. 674), 1958, oil on Masonite, 28 1/4 x 28 1/4, John Michael Kohler Arts Center, Sheboygan, Wisconsin

Wand of the Genii, 1958, oil on paperboard, 24 x 24, private collection, New York

Lyceum Imperalis (No. 828), 1959, oil on Masonite, 24 x 24, collection of Edward V. Blanchard and M. Anne Hill, New York

Untitled, 1961, oil on Masonite, 24 x 24, private collection, New York

Chicken Bone Throne, late 1960s, painted chicken bones, 7 x 4 x 3, courtesy of Carl Hammer Gallery, Chicago

Bone Chair, late 1960s, painted chicken bones, 6 x 4 x 4, courtesy of Carl Hammer Gallery, Chicago

JOSEPH YOAKUM

Red Mtn and Red Clay Pass in San Juan Range near Telluride Colorado, n.d., color pencil, watercolor, and ballpoint pen on paper, 19 x 12, collection of Jill and Sheldon Bonovitz, courtesy of Janet Fleisher Gallery, Philadelphia

Little Falls in Coredeleene River Near Coslo, Idaho, 1965, pen and pencil on paper, 18 x 24, collection of Jill and Sheldon Bonovitz, courtesy of Janet Fleisher Gallery, Philadelphia

Go Back Mtn Near Stratford New Hampshire, 1965, pastel, color pencil, and pen on paper, 12 x 18, collection of Edward V. Blanchard and M. Anne Hill, New York

Mt. Magazine Point in State Near Town of Havana Arkansas, 1967, color pencil, pencil, and pen on paper, 18 x 11 3/4, collection of Edward V. Blanchard and M. Anne Hill, New York

Mt Trinity of Clear Water Range Near Boise Idaho, 1968, pastel, ballpoint pen, and color pencil on paper, 12 x 18, collection of Edward V. Blanchard and M. Anne Hill, New York

Mt Cab Maisi Near Santiago Cuba (Guantanamo Bay), 1968, pencil and ballpoint pen on paper, 11 7/8 x 17 7/8, courtesy of Phyllis Kind Gallery, New York

Cambrian Mtn Range Near Denbiga (British Wales), n.d., pencil and blue ballpoint pen on paper, 11 7/8 x 17 7/8, courtesy of Phyllis Kind Gallery, New York

Mealy Mts Near Melville Labrador Highland Labrador, n.d., pencil and blue ballpoint pen on paper, 12 x 18, courtesy of Phyllis Kind Gallery, New York

Mt McKinnie Puget Sounds Northern Washington State, 1963, pencil and color pencil on paper, 12 x 18 7/8, courtesy of Phyllis Kind Gallery, New York

Bunker Hills near Town of Twin Oaks in Western Kansas, 1970, pen and ink and color pencil on paper, 12 x 19, collection of Robert M. Greenberg, New York

PURVIS YOUNG

Untitled (Five Large Figures), 1987, mixed media on board, 60 x 48, private collection, courtesy of Ricco/Maresca Gallery, New York

What People Be Doin', 1990, paint on paper and wood, 62 x 53, collection of Edward V. Blanchard and M. Anne Hill, New York

Truck Procession, ca. 1989, house paint on plywood, 82 x 38, collection of Mr. and Mrs. Selig D. Sacks, New York

WILLIE WAYNE YOUNG

Untitled, 1978, pencil on white paper, 18 x 12, private collection, courtesy of Ricco/Maresca Gallery, New York

Untitled, 1978, pencil on white paper, 18 x 12, private collection, courtesy of Ricco/Maresca Gallery, New York

Untitled, 1978, pencil on white paper, 18 x 12, collection of Chapman Kelly, courtesy of Ricco/Maresca Gallery, New York

Untitled, 1978, pencil on white paper, 18 x 12, private collection, courtesy of Ricco/Maresca Gallery, New York

Untitled, 1991, pencil on white paper, 18 x 12, private collection, courtesy of Ricco/Maresca Gallery, New York

Untitled, 1989, pencil on white paper, 18 x 12, collection of Chapman Kelly, courtesy of Ricco/Maresca Gallery, New York

Untitled, 1980, pencil on white paper, 18 x 12, collection of Chapman Kelly, courtesy of Ricco/Maresca Gallery, New York

Untitled, 1986, pencil on white paper, 18 x 12, collection of Chapman Kelly, courtesy of Ricco/Maresca Gallery, New York

Untitled, 1977, pencil on white paper, 24 x 18, private collection, courtesy of Ricco/Maresca Gallery, New York

Untitled, 1981, pencil on white paper, 24 x 18, private collection, courtesy of Ricco/Maresca Gallery, New York

Untitled, 1978, pencil on white paper, 24 x 18, collection of Chapman Kelly, courtesy of Ricco/Maresca Gallery, New York

Untitled, 1989, pencil on white paper, 24 x 18, private collection, courtesy of Ricco/Maresca Gallery, New York

Untitled, 1990, pencil on brown paper, 67 x 27 1/2, private collection, courtesy of Ricco/Maresca Gallery, New York